# Hertfordshire

## SECRETS &
## SPIES

# Hertfordshire

## SECRETS &
## SPIES

**Pamela Shields**

AMBERLEY

*To Unsung Heroes*

Photographs © Marac and Hanae Kolodzinski www.marack.net

First published 2009

Amberley Publishing
The Hill, Stroud
Gloucestershire, GL5 4EP

www.amberley-books.com

British Library Cataloguing in Publication Data.
A catalogue record for this book is available from the British Library.

ISBN 978 1 84868 788 2

Typesetting and Origination byAmberley Publishing
Printed in Great Britain

# CONTENTS

# ACKNOWLEDGEMENTS

Grateful thanks to:

My sons, Jeff and Steve, for putting up with me and granddaughters, Ella and Mia Shields, for all the hugs.

Marac and Hanae Kolodzinski for responding so positively and so quickly to my *cri de coeur* for photographs.

The hundreds of Hertfordshire folk who attend my talks and courses and inspired me to write this book, especially Hitchin U3A, Stevenage U3A, Welwyn Ladies' Probus and Buntingford Adult Learning For Fun (BALFF).

Doris, Michael and Noelle Devenish.

Andrew Cook.

Eleanor Rees and Tim Yates, BRE, Bucknalls Lane, Watford.

First Garden City Heritage Museum, Letchworth.

Hertfordshire Archives and Local Studies (HALS), County Hall, Hertford.

Hitchin Historical Society, Pauline Humphries.

Hitchin U3A, Mavis and David Bell, Barbara Alexander and Janet Surry.

Jeremy Smith, education facilitator, Rudolf Steiner School, Kings Langley.

John Harper of the Turing Bombe Rebuild Project.

Kristina Lawson Head, market information and promotion, Tun Abdul Razak Research Centre, Brickendonbury Manor.

Maggie Garrett, school librarian, Bishop's Stortford College.

Michelle Simpson, nursery performance manager, Busy Bees, Glenalmond King, Harry Lane, St Albans.

Neil Robinson, Ayot House, Ayot St Lawrence.

Peter Harkness.

Professor M. R. D. Foot.

Sarah Flight and Jessica Andrews, Amberley Publishing.

# INTRODUCTION

Writing an A-Z about Hertfordshire, I was amazed by how many writers lived or live in the county and this led to a book about them. Writing about the writers, I was amazed at how many of them worked in Intelligence. It seems that many writers are attracted to Intelligence work. Malcolm Muggeridge, who worked for MI6 (MI stands for Military Intelligence) in St Albans said, 'The spy must be observant, imaginative, alert to motives and capable of trafficking in lies. He must also by nature revel in secrecy and delight in danger or the prospect of danger.' This book, which is about what spies got up to, began as a talk given to Hitchin Leisure Group, Stevenage U3A, Welwyn Ladies' Probus and Hitchin U3A. It expanded into a ten week course for Buntingford Adult Learning For Fun (BALFF) and, like Topsy, it just grew.

Sinister. Dangerous. Glamorous. Espionage, the covert gathering of information, which Kipling called 'The Great Game', is all of these things, but as late as 1951, when KGB Agent Kim Philby was rumbled, it was said he resigned from the Foreign Office, MI5/MI6 did not officially exist. It's only now we are beginning to find out about the clandestine activities of some of the people who were once our neighbours. After their deaths it turned out that the unassuming woman who lived down the lane and worked for the BBC actually broadcast secret codes to agents in enemy-occupied countries during the war; her friend, a parish clerk in Ashwell, also worked in Intelligence. People you might have known all your life went to the grave never telling anyone they worked on the famous Alan Turing Bombe which helped crack the Enigma code. This book only scratches the surface of the many secrets in Hertfordshire.

Today, although it involves billions of pounds and sophisticated technology — we have spy satellites — the motives behind spying have not changed. From the beginning of recorded history, codes and ciphers have been used to carry secret messages, from plots against Elizabeth I to the Enigma machine. We call them spies; they call themselves intelligence agents. What's amazing is that so many were connected with Hertfordshire.

Forget the cloak, dagger and floppy hat; spies are, like John le Carré's George Smiley, inconspicuous. You just never know who you are rubbing shoulders with. A woman I had known for some time told me her husband was a pilot based at Tempsford and dropped secret agents into occupied France. After a talk in Buntingford assuring listeners they might very well be sitting next to an agent, one told me he was recruited by Nelson Mandela's ANC, and a sweet, gentle Miss Marple-type character told me that during the war she tested the secret one-man submarine at The Frythe in Welwyn.

Spying is often a family affair. Chaucer was a secret agent, as was his father and grandfather. The Bacon brothers, Anthony and Francis, were both spies, as were the Waugh brothers, Alec and Evelyn. Graham Greene's family was steeped in espionage.

Does spying do more harm than good? Did it keep the lid on the Cold War? What attracts people to spying? Patriotism? Idealism? Money? Adrenalin? Kim Philby's betrayal was a body blow to everyone who knew him, especially his wife. He made MI6 look like a bunch of morons. How they must have cringed when they remembered that new recruits to MI6 were advised to model themselves on Philby. And how he must have laughed.

# CHAPTER 1

# THE TEMPLARS

## THE WORLD'S FIRST SECRET SOCIETY

Da Vinci Code *aficionados* have no need to traipse all over Europe searching for the Holy Grail, it might very well be right here in Hertfordshire.

Although the Order dominated Europe for 200 years, apart from the Crusades, their past, even today, is shrouded in mystery. Secrecy was, of course, one of the Templar vows. MI5 and MI6 fade into insignificance beside the world's first secret society.

How come Hitchin had the infamous Templars for neighbours? Because the lord of Hitchin Manor, the crusader, Bernard de Baliol, built a huge preceptory (monastery cum manor house) for them nearby in what is now known as Preston. The most important in south-east England, Templars held their National Chapters (AGMs) in Hitchin preceptory. This was also one of the named places where their alleged crimes of devil worship, black magic, blasphemy, idolatry and sodomy took place.

Bernard de Baliol went on the second Crusade in 1160. His effigy, one of the earliest in England, on the window-sill in St Mary's church, Hitchin, originally showed armour, chainmail, a sword and a shield. To see its like, visit Temple Church in London. His legs are crossed to symbolise he went on Crusade. Made in 1162 when he returned from Crusade, the effigy was originally on his tomb in the Templar chapel in Preston.

A family to be reckoned with, it was Bernard de Baliol who built Barnard Castle. One of his descendants founded Baliol College Oxford; another became king of the Scots.

Near Hitchin Preceptory is St Ippollitts' (the spelling seems to be arbitrary) church. Founded by William the Conqueror's niece, Judith, St Ippolitts' was dedicated to Hippolytus, the patron saint of horses (the French do not aspirate hence 'ippo). The church is one of only two in the UK dedicated to the saint, the other is in Dorset. When the church was built, it belonged to St Mary's, Hitchin. Before going on Crusade, Templars brought their horses to the altar to be blessed, a tradition which St Ippollitts' church has recently revived (romance is not dead). The crosses on the pillars inside the church are believed to have been cut by the Templars.

A law unto themselves, the Templars, who swore allegiance only to each other, had agents all over the world concerning their financial dealings, naval operations and military plans. Their secret identification codes were even more essential when they were arrested.

When King Stephen gave the manor of Deneslai near Hitchin to the Templars, it became known as Temple Dinsley. Gilbert de Clare, Earl of Pembroke, gave the Templars nearby Baldock. The Arms of the town carry the red cross of the Knights and chevrons from the Arms of the de Clare's. In 1860, a bricked up room over the south porch of St Mary's, Baldock, was unsealed by the rector, Revd John Smith (the man who decoded Samuel Pepys diaries). Inside were armour and pikes said to belong to Templars.

When Sir Richard Montfichet, Sheriff of Hertfordshire (one of the barons appointed to enforce Magna Carta), died on Crusade his family gave Letchworth Manor to the Hitchin Templars. His heart was buried under the Church of St Mary The Virgin, Letchworth. A small stone effigy of a knight holding a heart is on the window sill. The Templars were also given nearby Buntingford.

Although their rivals, the Knights Hospitallers, had been escorting pilgrims to the Holy Land for years, the Templar Order was founded ostensibly to defend pilgrims; this was thought to be a ploy to enable them to excavate Solomon's Temple for Christian relics. A crystal phial of (purportedly) Christ's blood found beneath the temple was given to Henry III. When he ceremoniously presented it to Westminster Abbey, Matthew Paris, the chronicler monk of St Albans Abbey, who was an eyewitness, wrote an account of it. He was not a fan of the Order. In his *Chronica Majora* he said, '[The Templars] swallow down such great revenues as if they sunk them into a chasm of the Great Abyss!' He accused them of keeping Christians and Saracens fighting to prolong the war so that they could extort money from pilgrims. 'They used to be legitimate defenders of the Church, but then became destroyers of it and of peace, and even became its cruel exterminators.'

The Templars set up their HQ in a disused mosque known as the Temple of Solomon; hence the name — Knights of the Temple of Solomon. When they took Jerusalem from the Moslems, a grateful Pope set them above all authority answerable only to him. By 1307, however, they were so rich and so powerful they held all authority, including that of the Pope, in such contempt that the Pope issued a papal bull ordering the Templars to disband.

One of the most famous of the crusaders was Richard, son of Henry II and Eleanor of Aquitaine, who was born 8 September 1157 at Beaumont Palace, Oxford. The same night Hodierna Neckham gave birth to a boy, Alexander, in St Albans. Appointed Richard's wet-nurse, she reared him as Alexander's foster brother. Alexander Neckham was the first translator of *Aesop's Fables* and the first to write about chess, silkworms and the mariners' compass. He was educated at the Abbey School, St Albans, where he became a teacher. His foster brother Richard became king of England.

Richard I is said to be depicted in the famous Royston cave, next to him his queen, Berengaria, with her crown floating above, not on, her head, as she was never crowned (Richard died before he could bring her to England).

In 1291, with the loss of Acre and the ending of the Crusades, Templar days were numbered. They were by then richer and more powerful than any king, so Philip of France decided to get his hands on their fortune. When Pope Clement disbanded the Order, accusing the Templars of heresy, Philip arrested those in France. When he asked Edward II to close the Commanderies in England, Edward — living in Kings Langley with his lover, Piers Gaveston — refused.

Edward had problems of his own. When he went to France to prepare for his wedding to Princess Isabella (dubbed by the English the She-Wolf of France) and left Piers Gaveston in charge as Regent of England, he caused uproar. A hounded man himself, Edward had no appetite to hunt down Templars.

In the end, Edward was forced to arrest the six Templars in Hitchin. Two were sent to the Tower of London, four to the dungeons in Hertford Castle. When Edward told the Pope that torture was illegal in England, the Pope sent over ten of his own trained, skilled torturers, Dominican friars. Threatened with excommunication Edward allowed them into Hertford Castle but ordered 'No violent effusions of blood and no permanent wounds inflicted'. By this time, the Templars had been in Hertford Castle three years, lodged in comfortable quarters and allowed treats from their jailers.

Supported by unlimited finances, ships, horses, friends and Allies, many English Templars had already long gone to ground. Temple Farm in Bengeo and Royston Cave were said to be two of their hiding places.

The astonishing cave (cavern to be precise, as caves are natural formations), which is unique in the world, is under Melbourn Street. It has carvings of saints revered by Templars, including St Catherine, for whom the Templars had a special regard as it was on St Catherine's day 1177 that they won victory over Saladin. The carving of St Catherine here is depicted with the wheel she was martyred on. The two small figures below St Catherine are said to be the crusader, Richard I (Lion Heart), and his queen, Berengaria. Two figures close together under the entrance are remains of the familiar Templar sign of two knights riding the same horse.

When his beloved Piers Gaveston was murdered, Edward II had his body brought to Kings Langley and gave him a lavish funeral. When Edward was murdered in Berkeley Castle, his jailers were instructed to leave no marks on his body. According to Sir Thomas More, 'On the night of October 11 (1327) while lying in bed [the king] was suddenly seized and, while a great mattress ... weighed him down and suffocated him, a plumber's iron, heated intensely hot, was introduced through a tube into his secret parts so that it burned the inner portions beyond the intestines.' Edward was buried in secret in the dead of night in Gloucester Cathedral. Piers Gaveston might very well be still in Kings Langley somewhere (call in the Channel 4 Time Team!).

Convinced the Templars had buried a fortune in Hitchin preceptory, Edwards' son, Edward III, set up a royal commission 'To inquire touching concealed goods of the Templars in the County of Hertfordshire'. Nothing was found.

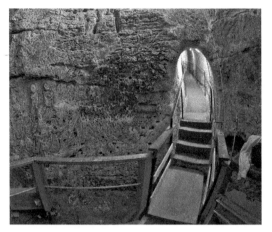

*Royston Cave*

There are no remains above ground of the Hitchin Preceptory. Skeletons, a chalice and a grave slab were found during building work in the location of the Templar chapel. When two wings were added by Edwin Lutyens for the Fenwick family, thirteenth-century floor tiles were found where the Templar Hall stood.

The house was bought by Douglas Vickers, the armaments man. He sold it to the Countess of Caernarfon. She sold it in 1935 to Princess Helena College for Girls (Helena was the third daughter of Queen Victoria).

Inside nearby St Martin's church is a thirteenth-century coffin lid from Dinsley, and in Walkern church, beneath an arch on the south wall, is a defaced effigy of a Templar.

In 2004, the *Hertfordshire Mercury* reported on a network of tunnels beneath Hertford. Their existence had been leaked to a journalist by a member of a secret society with, they say, links to the Templars. Were the tunnels made by the Templars when they were in Hertford Castle? They run under the castle dungeons, tourist office, post office, Magistrates' Court and Blue Coat School. Members of this secret society, who meet in the tunnels, say, 'Hertford's labyrinth could provide proof that the Templars disappeared underground — literally and metaphorically'. It's rumoured that Cardinal Joseph Ratzinger, Pope Benedict XVI, carrying out his own investigations on the Templars contacted Dr Alan Thompson at the University of Hertfordshire and Hertfordshire County Council's environmental records officers.

# CHAPTER 2

# GEOFFREY CHAUCER

## Who Knew Where the Body was Buried?

There can't be many who do not know that Geoffrey Chaucer wrote *The Canterbury Tales*. No one, however, knows when or how he died. Terry Jones, in his book *Who Killed Chaucer*, speculates that Chaucer was done away with. Small wonder if he was. Chaucer knew that not only had Henry Bolingbroke arranged to have Richard II murdered in Pontefract Castle but that his corpse was hidden in Kings Langley.

Chaucer was Richard's Clerk of the King's Works, responsible for Berkhamsted Castle, of which only a few stones survive. He also looked after the palace at Kings Langley. He would be sad if he saw it today. Once as big as the Palace of Westminster, nothing apart from an outbuilding is left.

Edward III renovated Berkhamsted Castle for the Black Prince when he created him Duke of Cornwall. It still belongs to the Duchy. Prince Charles has visited. The palace at Kings Langley was so important that, during the great plague of London in 1349, the seat of government relocated there. Edward II, Edward III and Richard II loved Langley, which is mentioned in Shakespeare's *Richard II*.

Chaucer had many connections with Hertfordshire. As page to Prince Lionel, Edward III's son, he stayed at Hatfield House; he was also a lifelong friend of Edward's other son, John of Gaunt, who lived in Hertford Castle. In *The Canterbury Tales*, the world's most famous pilgrimage, the cook comes from Ware, which is also in Hertfordshire. The Doctor of Physick was his friend John of Little Gaddesden, the first English court physician (to Edward II and III). The first reference to the first paper mill in Britain referred to Mr Tate of Hertford who supplied the paper to William Caxton to print the first edition of *The Canterbury Tales*. The book was run off the press for Henry VII when he visited Tate's paper mill while staying at Hertford Castle.

When Richard was taken to Pontefract Castle and murdered, like Edward II before him, orders were given that no marks must be found on his body. It's thought he was starved to death.

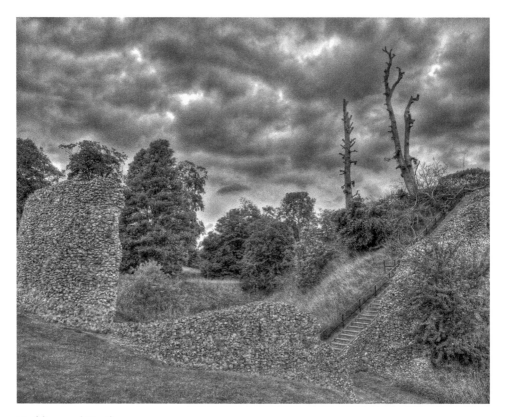

*Berkhamsted Castle*

Although Henry Bolingbroke proclaimed himself king and took the throne as Henry IV, his son, Henry V, said Richard was on his father's conscience until the day he died. Henry V removed Richard's remains from Kings Langley and reburied them in Westminster Abbey.

When Bolingbroke took power, many of Chaucer's friends were executed. Chaucer, known as a secret agent for Richard II in possession of state secrets, claimed sanctuary within the confines of Westminster Abbey and was never seen again. There is no record of his death, even though he was famous because of *The Canterbury Tales* and a member of the royal family (he married Phillippa Roet, sister of John of Gaunt's wife, Katherine Swynford).

Chaucer, like his father and grandfather, was in royal service all his life until he was too old for 'The Great Game'. Sent on secret missions to Paris, Genoa, Florence, Padua and Milan, he invented secret cryptograms for John of Gaunt. He was captured while fighting with Prince Lionel and John of Gaunt with Edward III's army near Rheims during The Hundred Years War. The king paid a huge ransom for his release and granted him a life pension.

Chaucer's lifelong friendship with John of Gaunt began when they were boy pages to the Countess of Ulster in Yorkshire. When he married, the duke moved into Hertford

*Kings Langley*

Castle with his first wife, Blanche, who died of plague. Chaucer's *Book of the Duchesse* is an elegy to her in which the narrator, strolling through a wood, stumbles on John, a mysterious, mournful man in black.

Richard II appointed Chaucer Clerk of the King's Works, in charge of hundreds of craftsmen, bricklayers, roofers and labourers with responsibility for repair and maintenance of all-important royal buildings. He resigned after being mugged several times and relieved of the men's wages.

# CHAPTER 3

# WILLIAM CECIL

## OF THEOBALDS

If it were not for three men who lived in Hertfordshire, Elizabeth I would not have died in her bed of old age, she would have been assassinated. From 1558, when she was crowned, until 1603, when she died, Elizabeth was saved from every attempt on her life by William Cecil (Baron Burghley) of Theobalds Palace in Cheshunt, Robert Cecil (Viscount Cranbourne) of Hatfield House (William's son), and spymaster general, Sir Francis Walsingham of Park Street. All were devoted to her; they trusted no one and suspected everyone.

*Theobalds Park*

Sir William Cecil built a magnificent palace in Theobalds Park where Elizabeth stayed at least eight times (one visit lasted six weeks). Partly demolished by Oliver Cromwell, present-day Theobalds Park was built in 1763. The old palace was east of today's Theobalds Park. The ruins, a Scheduled Listed Monument, can still be seen.

Cecil loyally served Edward VI, Mary I and Elizabeth I. Still in his thirties when Elizabeth became queen, he was her spokesman in parliament and her chief advisor for forty years until the day he died because Elizabeth would not let him retire. He was elevated to Lord Burghley thirteen years into her reign.

William told his son, Robert, who would one day, by default, own Hatfield House where Elizabeth I grew up, his aims were to keep England away from wars which drained the treasury, reconcile the queen to her enemies and ensure a peaceful succession.

To protect the queen he created a worldwide intelligence-gathering service, the forerunner of MI5 and MI6, and put Sir Francis Walsingham in charge.

Baron Burghley's descendant Robert, Baron Cecil, Lord Salisbury, Viscount Cranborne, negotiated terms for the House of Lords Act 1999 in which the automatic right of hereditary peers to sit in the upper chamber of Parliament was abolished. He managed a compromise with the Labour government of Tony Blair. Ninety-two selected hereditary peers were allowed to remain on an interim basis. Agreed without consulting Conservative Leader William Hague, Lord Salisbury was dismissed as Conservative Leader in the House of Lords.

# CHAPTER 4

# ROBERT CECIL

---

## OF HATFIELD

It was William's son, Robert Cecil, the first Earl of Salisbury, who built Hatfield House. Born into the queen's service, a protégé of Walsingham, he was trained from an early age in spy craft. Slightly hunchbacked, Elizabeth called him 'my elf' or 'my pigmy' which infuriated him, as did James I referring to him as 'little beagle'.

Robert, who studied at St John's College, Cambridge and the Sorbonne, Paris, was M.P. for Hertfordshire. He married Elizabeth Brooke, daughter of Lord Cobham.

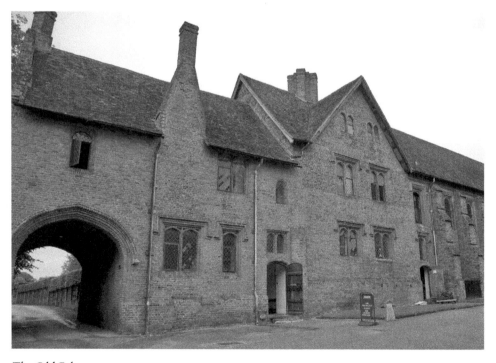

*The Old Palace*

When he was knighted by the Queen at Theobalds Park, Robert, sworn in as a privy councillor, was, at twenty-eight, its youngest member. He carried out the tasks and duties of Secretary of State long before he was appointed to the position.

It was Robert Carey who rode to Scotland to tell James VI he was now also James I of England. Cecil's good relations with James ensured a peaceful succession.

Robert Cecil was told of the Gunpowder Plot through his friend William Parker, Lord Monteagle of Furneux Pelham in Hertfordshire. A Roman Catholic, it was Monteagle who received the famous letter warning him not to attend Parliament on 5 November. When the letter (now in the Public Records Office, Kew) was delivered, King James was hunting at Royston in Hertfordshire.

In 1607, Robert Cecil was 'persuaded' to swap the grand palace at Theobalds Park, which his father built and loved, for the crumbling, derelict Hatfield House (built in 1485 for the bishop of Ely) where Henry VIII's children were brought up. Apart from the historically important Banqueting Hall in The Old Palace where Elizabeth I held her first council as queen in 1558, Cecil demolished it to build the present house. The Old Palace, a wonderful example of medieval brickwork, which still has most of its original roof timbers, was used as stables.

James I loved Theobalds, where he stayed often. When he died there, Charles, his son, was proclaimed king at the gates of nearby Cedar Park.

# CHAPTER 5

# FRANCIS WALSINGHAM

## OF PARK STREET

Sir Francis Walsingham of Park Bury (demolished) near Park Street, St Albans, like the Cecil family, was devoted to Elizabeth. She, however, was not devoted to him. His daughter, Frances, was a love rival. When Frances' first husband, Sir Philip Sydney, died fighting in Holland with the Earl of Leicester (another of the queen's beaus) she married Robert Devereux, Earl of Essex, Elizabeth's current toy boy, in secret. The queen was furious whenever she lost a suitor. Despite the Cecil's pleading with her on his behalf, she deliberately kept Walsingham short of funds.

Walsingham, a lawyer, highly intelligent, serious and self-disciplined, began his career as William Cecil's protégé but left England rather than serve under the Catholic Mary Tudor. When Protestantism was re-established under Elizabeth, he was recalled from France and appointed Secretary of State. The Rainbow Portrait in Hatfield House shows the queen's gown embroidered with eyes and ears, a public nod to Walsingham's spy network, the largest the world had ever seen. Elizabeth's fiercely patriotic spymaster general bankrupted himself in her service. He paid agents in Spain, Nantes, Rouen, Le Havre, Dieppe, Cracow, Genoa, Brussels, Leyden and Denmark from his own pocket. He placed agents throughout Europe in the Catholic courts of Spain, Italy and France.

Elizabeth was under threat throughout her reign but Walsingham unearthed every plot to overthrow her. It is a testament to him that Elizabeth died in her bed of old age. Her enemies were anyone who wanted a Catholic succession. Think Armada, Mary Queen of Scots, Thomas Howard, Ridolfi and Babington.

Walsingham ordered the Lord Mayor of London to send him weekly reports of all foreigners in the city. He uncovered Britain's first double agent, Sir Edward Stafford, Ambassador to Paris on English and Spanish payrolls. When he uncovered the plot for the Spanish Armada, he bribed Genoese bankers to delay loans to Philip of Spain.

Spies allowed Walsingham, hundreds of miles away in England, to find his enemies in Europe. Foreign ambassadors were essential, but Walsingham, like the KGB, recruited

Oxbridge undergraduates. He also raided prisons. One ex-convict managed to get his hands on the papal code. Walsingham taught agents to crack and invent codes so they could write to each other in secret. Letters penned in ink concealed coded messages written in milk or lemon juice invisible until the paper was heated over a candle flame. One is on show at Hatfield House. He trained them how to intercept and decipher letters, create false handwriting and break and repair seals without detection.

England was isolated in Europe. It alone had a Protestant monarch. The pope excommunicated Elizabeth I and issued a fatwa instructing all Catholics it was their duty to kill her. Armed with information from spies based in this country, Walsingham could trace lines of communication between Catholics here and abroad, and keep track of any plots.

One of his spies in Europe was Christopher Marlowe. Another was Anthony Standen, a Roman Catholic. Walsingham sent Standen to Rome to find out the Pope's intentions. Despite a knighthood from Elizabeth, he was never able to reconcile loyalty to his religion with service to Queen and Country.

Walsingham needed to find out if and when Spain was going to invade. Standen's intelligence reports on the Armada made him a key figure in the Elizabethan secret service. He told Walsingham that Philip II of Spain was indeed planning an invasion. Using his contact network to subvert Philip's bankers, Walsingham managed to delay it for a year, then neutralised Spanish spies in Britain. Francis Drake used Standen's intelligence to attack the Spanish fleet at Cadiz, seriously damaging the intended invasion. By the time Standen returned to England, Walsingham had died, so he received no welcome home.

When Mary Queen of Scots arrived on English soil she was a magnet for conspiracy, a focus for Catholics. Walsingham used a double agent, a man working for him while appearing to work for Mary. Letters sent by Mary were found, their codes deciphered and The Ridolfi Plot to kill Elizabeth was uncovered. When he also uncovered the Babington Plot he convinced a very reluctant Elizabeth to have Mary executed. She never forgave him. Walsingham bankrupted himself in service to the queen and died deeply in debt.

# CHAPTER 6

# FRANCIS BACON

### OF ST ALBANS

Since William Cecil was married to Mildred Cooke, sister of their mother, Lady Anne Bacon of Gorhambury, St Albans, the Bacon brothers, Francis and Anthony, expected high office. They were disappointed.

The Bacon brothers spied for the Cecils and Walsingham. Anthony and his more famous brother, Francis, were the sons of Sir Nicholas Bacon and Lady Anne, daughter of Sir Anthony Cooke, private tutor to Edward VI. Elizabeth admired self-made men such as Nicholas. She appointed him Lord Keeper of the Great Seal, knighted him (she knighted very few) and made him a member of the Privy Council.

Gorhambury was owned by Anne's sister, Lady Margaret Rowlett, wife of Sir Ralph Rowlett. Sir Nicholas Bacon bought the house after their deaths. Anne's other sister, Mildred, who married William Cecil, Lord Burleigh, Secretary of State, lived at Theobalds in Cheshunt. When Sir Nicholas demolished Gorhambury to build new Gorhambury he took his boys with him to supervise the builders. He was the first to have piped water inside a house circulated via a pumping engine. Later a long gallery was added because, on her first visit, the Queen teased Sir Nicholas over his small house. The Queen, on her second visit, stayed five days. The romantic ruins, looked after by English Heritage, can be seen very near present-day Gorhambury House, built in 1777, owned and lived in by the Earl of Verulam.

When the family moved into Gorhambury, Sir Nicholas found the boys a private tutor from St Albans Grammar School. The Bacon brothers' high family connections did not bring them wealth while Elizabeth was alive. Blatant homosexuals, their advancement was blocked by the personal enmity of their cousin, Robert Cecil.

Francis, fascinated with cryptography, helped Walsingham decode correspondence and invent ciphers. He said the 'virtues' of perfect ciphers are 'that they be not laborious to write and read; that they be impossible to decipher; that they be without suspicion'. His own were extremely laborious. Some were designed to conceal messages in the pages of books, which meant the printer had to use two typefaces. The fonts must differ but not

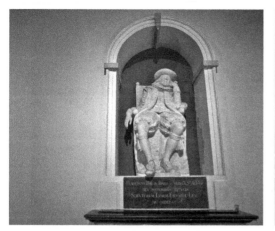 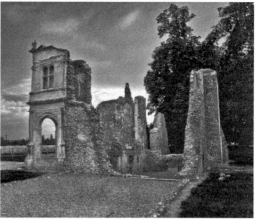

*Francis Bacon: St Michael's Church, St Albans    Old Gorhambury*

to the naked eye. One code was the Bilateral Cipher which reduces the twenty-six letter English alphabet to a series of five letter characterisations based on the lower-case letters of 'a' and 'b'. This became the basis of the Morse code and the binary code, which allows computers to communicate with each other. Bacon's 'a' is 'o' his 'b' is '1'. The Bacon Cipher is now the ASCII (American Standard Code for Information Interchange) Code.

Elizabeth I commissioned Francis to report on the 'Laws, religion, military strength and whatsoever concerneth pleasure or profit' in Europe. Anthony advised him on the route through France, Spain, Austria, Germany, Portugal, Poland, Denmark, Sweden, Florence, Venice, Mantua, Genoa and Savoy. Francis was away for a year. On his return, his report was presented to the queen, 'State Paper. Notes on the Present State of Christendom'.

Anthony, appointed The Queen's Intelligencer, was sent by his uncle William Cecil, Lord Burghley, to live in Europe to gather political intelligence. When Walsingham died and Anthony returned home, he and Francis lived together in London. Anthony was appointed director of Intelligence to Robert Devereux, Earl of Essex.

Their mother wrote to them from Gorhambury to say that, given their scandalous homosexual lifestyle, it was no wonder the queen and Cecil wanted nothing to do with them. The brothers visited her only when they had to. Anthony preferred to stay at his house at Redbourne (since lost an 'e') near Harpenden inherited from his father. He sold Barley Manor near Royston to clear debts.

He and Francis communicated with spies all over Europe. They arranged safe houses, new identities and new passports for agents returning from abroad and found them employment among the aristocracy.

When Francis was arrested for debt, he wrote to his cousin, Robert Cecil, for help. The begging letter was found at Hatfield House in 1760. When Anthony sold Redbourne Manor and Napsbury Manor near St Albans to clear more debts, Anthony also tried to sell Gorhambury over his mother's head but this was not legally possible while his mother was

*The Pulpit from Old Gorhambury: St Michael's Church, St Albans*

still living there. When Anthony died — no record was made of when, why or how — Francis inherited Gorhambury.

When James I, a practising homosexual nicknamed Queen James, succeeded Elizabeth, Francis Bacon enjoyed a rapid rise to fame and fortune. Within a very short space of time he was knighted for his proposal for a plan to unite England and Scotland, appointed Commissioner for the Union, King's Counsel, Solicitor-General, Clerk of the Star Chamber, Chief Advisor to the Crown, Attorney-General, privy councillor, Lord Keeper of the Great Seal ('Keeper of the King's conscience' acting as Regent), Lord High Chancellor (highest public post next to the throne) and raised to the peerage, Baron Verulam (which he was made on his sixtieth birthday) and first Viscount St Albans (this title became extinct on his death).

He thought he was inviolable. He was not. Parliament loathed homosexuals, especially Bacon, James and his lover, Buckingham; it couldn't get rid of the king or Buckingham but it could dispense with Bacon. It impeached him — a criminal trial initiated by the House of Commons with the House of Lords acting as judges. Long fallen into disuse but still on the statute books (as it still is today) it was revived by Sir Edward Coke specifically to get rid of Bacon.

The plot was hatched almost immediately upon his receiving the last title at the height of his public glory. Impeached on twenty-three counts of bribery, corruption and perverting the course of justice, Bacon frantically sought an audience with the king but was refused. The king, who felt threatened, ordered Bacon to plead guilty.

A fellow M.P. said Bacon's fall was due not to corruption but to 'an unnaturall crime'. Bacon's sentence included a fine of £40,000 (£6 million), imprisonment in the Tower, a ban from ever again holding office, an exclusion from Parliament and the verge of court (12 miles radius from anywhere the sovereign is in residence). He lost everything: fame, fortune, freedom and name. Publicly humiliated, he was remanded in Gorhambury at His Majesty's Pleasure. Although a severe blow, it enabled him to devote himself to his real love, writing.

# CHAPTER 7

# JOHN THURLOE

## CROMWELL'S SPYMASTER GENERAL

Who protected the Protector? A man whose name few today remember, John Thurloe, Oliver Cromwell's Secretary of State, foreign secretary, home secretary, chief of police, war secretary, postmaster general, spymaster general and head of the secret service. His correspondence is one of the chief historical sources for the Cromwell era.

Royalists, naturally, wanted Cromwell dead. John Thurloe enters the scene. Born in Essex son of Thomas Thurloe, rector of Abbot's Roding, he trained as a lawyer in Lincoln's Inn. Like Francis Walsingham, he developed an impressive network of spies in Britain and Europe. Unlike Walsingham, who was given no budget, Thurloe was able to pay £1,000 to anyone providing good information.

He hired mathematician John Wallis to set up a cryptology department to break secret codes and dismantle The Sealed Knot, the Royalist secret society. Thurloe managed to foil all their plots by infiltrating the society with his own agents.

Today, his name is remembered in Thurloe Square and Thurloe Place, Kensington, but, although he lived in Kensington, he didn't own property there. His name lives on through his daughter, Ann, who did.

The consensus of opinion is that Thurloe had a country estate in Stevenage old town. Cromwell's Hotel, now on the site, was known locally for many years as Thurloe's Farm.

There are no documents to prove he owned land here or any to prove he did not. The Thurloe papers are said to be about his work with nairy a glimpse of his private life. This is not surprising, as given that it was his practice as Post Master General to intercept and open all mail, he rarely wrote letters.

In May 1659 when Thurloe was dismissed by parliament — it voted for the Restoration — he lost his official residence. No one knows where he took his family to live. Was it Stevenage, not far from the centre of the action? Now in forced retirement, did he farm here? If so, do any bits of Thurloe's place survive on the site? No one knows where he lived when he was released from the Tower either, until he fetched up later in Wisbech.

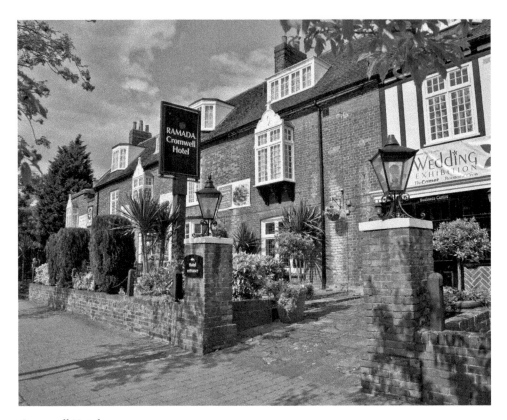

*Cromwell Hotel*

According to Philip Aubrey in *Mr Secretary Thurloe* — one of the very few biographies of him — Thurloe's home life was loving and happy. His first wife died after four years of marriage. Six years later, he married Ann Lytcott, daughter of Sir John Lytcott, knighted by James I. The couple had four sons and two daughters.

Thurloe ran an oppressive security system to block Royalist restoration plots. He divided England into spy rings, each with its own spymaster major general. Neighbours, encouraged to inform on neighbours, were offered financial rewards

As famous in his day as Francis Walsingham was in his, Thurloe was unreservedly loyal to Oliver Cromwell, a man he revered. He was equally close to Cromwell's son, Richard.

After Cromwell, Thurloe was the most powerful man in the country. Apart from the days he was ill — he did not enjoy good health — he saw the Protector every day. As one of Cromwell's very few confidants he was said to be 'the very soul of government'.

Having started a revolution, Cromwell made ready for a counter-revolution. Indeed, there were so many Royalist plots to assassinate him, he wore armour under civilian clothes.

When a cache of letters belonging to Charles I was found after the battle of Naseby, Dr John Wallis of Oxford University cracked the codes. After that, Thurloe, on constant lookout for subversive plots, ordered that all letters be intercepted in a room next to the

sorting office. Thurloe's trusted assistant, the inventive Samuel Morland, told that the Spanish had invented a method of sealing letters so that it was impossible to open them without leaving a trace, found a way. The problem was that Morland had defected to the Royalist side. Thurloe was betrayed in the time-honoured way Intelligence organisations are often betrayed: by the mole within.

Sir Richard Willis wanted to lure Prince Charles — in secret correspondence referred to as Mr Cross, Mr Knox or Tom Giles — and his brother, James, to land on the Sussex Coast under pretence of meeting Royalists. They would then be eliminated. When he put his proposition to Cromwell and Thurloe, Morland pretended to be asleep at his desk in the corner of the room. When Cromwell suddenly noticed Morland, he became alarmed but Thurloe said that as Morland had worked through the night he was definitely sleeping. Morland, shocked by the plot, turned to the Royalist side.

When Oliver Cromwell died, John Thurloe supported his son Richard Cromwell.

After the Restoration, Thurloe was arrested for high treason but was never brought to trial. He was released on the condition he relinquished all secret government documents. Charles II was not a vindictive man. He pardoned all those not personally responsible for his father's death.

Thurloe, held in the Tower, missed the Restoration festivities when Charles II entered London on his birthday. On that day, all that Thurloe had slaved for over eight years was over.

Having spent six weeks in the Tower, Thurloe was released, his knowledge and experience at the disposal of the king. It's said that Charles often urged him back into office but Thurloe refused, telling the king that Cromwell sought men for places, not places for men.

He must have been devastated when his hero was dug up in 1661 on the twelfth anniversary of the death of Charles I. Cromwell was taken from Westminster Abbey, displayed at Tyburn (Marble Arch), pelted with unmentionables and his remains thrown in a pit.

Dubbed 'The Merry Monarch', Charles II's reign was anything but merry. Bubonic plague, the worst since medieval days, hit Britain, then came The Great Fire of London followed by the Dutch invading the Medway, burning English warships.

The king's brother, who succeeded him as James II, was a huge admirer of Thurloe; indeed Thurloe was admired internationally. Completely incorruptible, he forbade the use of torture under interrogation. One writer, opposed to everything he stood for, said Thurloe took no man's money, invaded no man'S privileges and did not abuse his own authority even though all foreign and domestic affairs were laid at his door.

Thurloe, accepting the Restoration as the will of the people, said it was far preferable to the anarchy which could have happened when Britain lost its strong leader. One thing achieved during the interregnum was that Charles I's insistence on the divine right of kings was discredited forever.

Thurloe, the consummate public servant who worked sixteen-hour days, was so busy that people begged for just ten-minute interviews. Dependable, indispensable, ill on and off for the eight years of the Protectorate, he died just two years after the Restoration at the age of fifty-one of a massive heart attack brought on by stress and overwork. Buried in the chapel of Lincoln's Inn he died having done his very best for his god, his country and his family.

Thurloe, while in office, for obvious reasons, seems to have had his portrait painted only once. There are copies at Chequers, in the Cromwell Museum Huntingdon, the National Gallery and in the office of the present head of MI5.

# CHAPTER 8

# ANN AND RICHARD FANSHAWE

## SPYING FOR THE PRINCE OF WALES

Few outside the town of Ware know about the dashing Richard Fanshawe of Ware Park (demolished) and his wonderful, fecund wife, Ann Harrison of Balls Park (still there) near Hertford. Ann's father was staunch Royalist John Harrison, who gave ill-fated Charles I £17 million in today's money to pay the Scots to fight for him and was bankrupted by Oliver Cromwell (along with other Hertfordshire gentry, including the Fanshawe's of Ware Park who had been there since 1575).

Some Royalist families found refuge in Oxford where, at Wolvercote Church at the height of the Civil War, Ann, sixteen, married Richard, thirty-five, mentor to the fourteen-year-old Prince of Wales. They dedicated their lives to bringing about the placing of the crown of England on the head of Charles; luckily, they lived to see the coronation.

Ann and Richard had a lifelong love affair and were also great diplomatic partners. Ann gave birth to fourteen live children and had six miscarriages.

Richard, son of Sir Henry Fanshawe, was one of ten children born at Ware Park. One brother, William, married Mary Walters, the half sister of the Duke of Monmouth. One, Simon, married the widow Ferrers, mother of the millionairess Katherine Ferrers, the so-called Wicked Lady of Markyate Cell near Wheathampstead. Another, Thomas, married Katherine Ferrers. Richard's nephew married Sarah, John Evelyn's daughter.

When Prince Charles sent 'Dick' to Spain to ask King Philip to fund his cause he was unable to pay him, so made Dick a baronet. Ann went with him. Thinking it safer to leave from Ireland, they arrived in Galway to find it in the grip of plague, so they skirted the city walls wading through infested rubbish. Knee-deep in dung, dirt, rags and fleas they boarded a Dutch merchant ship bound for Malaga. At Gibraltar the ship was attacked by pirates. Ann, locked out of harm's way below deck, paid the cabin boy sixpence for his clothes and joined her husband on board to fight. They often laughed about it in later years. On their return, the boat sailed into a storm and ran aground.

*Richard Fanshawe memorial*

The Fanshawe's Manor of Ware included neighbouring Bengeo, Thundridge and Wadesmill. Dick and Anne were living in Bengeo when their daughter Elizabeth was born.

Fighting with Prince Charles at the Battle of Worcester, Richard was captured and put in solitary confinement in prison at Whitehall. Ann took rooms nearby and every night lit a lantern and went to his window to talk with him, often in rain so heavy it went 'in at my neck and out at my heels'. Seven years later he managed to escape to France.

When Cromwell refused Ann permission to join him, she went to Wallingford House, the Petty France of its day, got papers under her maiden name, hired a barge to take her and her children to Gravesend, from there boarded a coach to Dover and crossed the channel.

When Oliver Cromwell died and his son Richard was ousted, Prince Charles invited Dick and Ann to join him in on board ship on his triumphal return to England as its king. Charles rewarded Dick with the title Viscount Fanshawe. He represented Hertfordshire in parliament. Balls Park was returned to the Harrison's. When Fanshawe was appointed Ambassador to Portugal, Charles gave him his miniature to negotiate his marriage. Ann and her daughters were presented to the queen who, she said, was dressed in black, sat in a black velvet chair on a black velvet carpet. The queen's daughter, Catherine of Braganza, married Charles II.

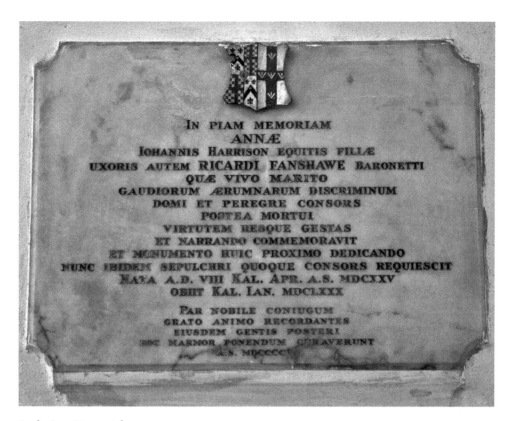

IN PIAM MEMORIAM
ANNÆ
IOHANNIS HARRISON EQUITIS FILLÆ
UXORIS AUTEM RICARDI FANSHAWE BARONETTI
QUÆ VIVO MARITO
GAUDIORUM ÆRUMNARUM DISCRIMINUM
DOMI ET PEREGRE CONSORS
POSTEA MORTUI
VIRTUTEM RESQUE GESTAS
ET NARRANDO COMMEMORAVIT
ET MONUMENTO HUIC PROXIMO DEDICANDO
NUNC IBIDEM SEPULCHRI QUOQUE CONSORS REQUIESCIT
NATA A.D. VIII KAL. APR. A.S. MDCXXV
OBIT KAL. IAN. MDCLXXX

PAR NOBILE CONIUGUM
GRATO ANIMO RECORDANTES
EIUSDEM GENTIS POSTERI
HOC MARMOR PONENDUM CURAVERUNT
A.S. MDCCCCV

*Lady Ann Memorial*

Richard Fanshawe died in Spain in 1666. Ann brought his body back to Hertfordshire but did not have the money to bury him until 1670 in All Saints', Hertford, near her childhood home. After hounding the government to pay her £5,900 in back-pay owed to Richard, she bought a vault for him under the south transept of St Mary the Virgin in Ware. His coffin was discovered in 1908. Thirty members of the Fanshawe family are buried in the church. His vault and monument cost Ann a small fortune. A full history is in the *Church Guide*.

Ann Fanshawe wrote her hair-raising memoirs for her surviving child. Born deaf and dumb, he died in Clerkenwell in 1694. Published in 1829, you can read them in Central Resources Library, Travellers Lane, Hatfield.

Ann, who mourned Richard for the rest of her life, was buried near her husband. Her memorial is in the Lady Chapel.

# CHAPTER 9

# RICHARD CROMWELL

## TUMBLEDOWN DICK

How did it come about that Oliver Cromwell's son, his highness Richard, Lord Protector and chief magistrate of England Scotland and Ireland, known as Lord Richard or Prince Richard, ended up in Cheshunt in rented rooms using the name John Clarke?

A decent man who inherited terrible problems, his downfall came about through trying to support Parliament against the army. He was dubbed Tumbledown Dick because his rise and fall from power was so swift.

In 1657, Richard sat next to his father in the state coach and stood next to him during the ceremony of his second installation as Protector. The following year, Oliver Cromwell was buried in Westminster Abbey with a grand funeral service based on that of James I.

Richard's succession was generally well received apart from a group of army officers who petitioned for the appointment of a soldier as Commander-in-Chief rather than Richard, who, unlike his father, had not won their trust and loyalty in battle.

The Council of State was divided between a military group headed by General Fleetwood and a civilian group headed by John Thurloe. Army officers were suspicious of Thurloe's influence over Richard. Their discontent was made worse because army pay was in arrears. Richard promised to do all he could to clear them. His tactful approach quietened the army for a time and won him support.

In order to raise much-needed finances, Richard called The Third Protectorate Parliament and gave an impressive opening speech. Following several weeks' debate, M.P.s endorsed his authority. However, when parliament began debating the reorganisation of the army, Fleetwood demanded the dissolution of parliament. Richard refused to comply. He called on the army to rally to him but the soldiers unanimously followed their officers, so Richard was forced to dissolve parliament.

When General Monck, officer in charge of the English army, marched on London, Richard was held under house arrest at Whitehall Palace. Parliament reassembled 7 May 1659 and voted to abolish the Protectorate.

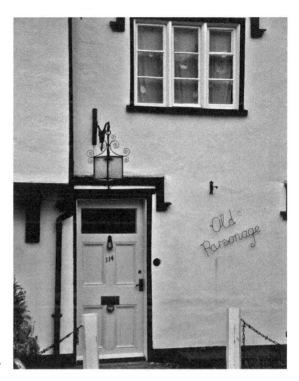

*Old Parsonage*

Richard, thirty-one, was promised Somerset House in the Strand and a pension of £20,000 p.a. Loyal followers offered to fight for him, but after witnessing the carnage of the Civil War, he said he would rather abdicate than one drop of blood be shed on his behalf.

When eleven members of the House of Commons who signed Charles I's death warrant were hunted down and hanged and his father's body dug up and displayed at Tyburn Richard feared for his life. Calling himself John Clarke, he left for France with his family. He and his adored wife, Dorothy Major from Hursley in Hampshire, had been living in luxury on the Major estate. Of their nine children, four survived.

Richard was devastated when Dorothy died in France in 1675. Still going by the name of John Clarke, he secretly slipped back into England and headed for Hertfordshire where he had once owned Cheshunt Park, a seventeenth-century estate (now a public open space and golf course).

He moved into Pengelly House near St Mary's church in Cheshunt. His landlord was old friend Sergeant, then Baron, Pengelly, to whom he paid 10s rent a week. Pengelly House burnt down in 1888. It's thought that Old Parsonage in Churchgate was built on or near part of the site.

Living incognito, Richard dressed like a poor farmer and saw Queen Anne on the throne he once graced. When his son, Oliver, died in 1705, he moved back to Hursley where he lived as lord of the manor until he died aged eighty-six in 1712. He was buried inside Hursley church.

# CHAPTER 10

# HENRY GUY

## UNEASY LIES THE HEAD THAT WEARS THE CROWN

How many have ever heard of Henry Guy? Even in Tring where he lived the odds are not many. People have, however, heard of The Rye House Plot hatched on his watch.

Having, of necessity, been a spy all his life — in fear for his life — Charles II had no need of a spy setup like that of Francis Walsingham or John Thurloe. He divided responsibilities for intelligence gathering between himself; his brother James; his mistresses at the French court; Sir William Morrice, Secretary of State; and his boon companion, Colonel Sir Henry Guy, M.P. for Yorkshire, Groom to the Bedchamber and Clerk of the Treasury. As Guy controlled all secret service finances, it was very probably him who uncovered The Rye House Plot.

The only son of Henry Guy of Tring and Elizabeth Wethered of Ashlyns, Berkhamsted Henry Guy II, was a member of Gray's Inn and Inner Temple and a student at Christ Church, Oxford. A close friend of Prince Charles during his exile in Holland, he probably knew the Cromwells, John Thurloe and the Fanshawes. After the Restoration, with fingers in many pies, he became wealthy, rewarded handsomely for what can only be called 'pimping' for the king. Charles gave him the commissionership for street cleaning and the licensing of hackney coaches and wine. He also gave him Tring Manor, which had belonged to Charles' mother, Queen Henrietta Maria.

Guy became prominent in Hertfordshire, holding various offices, including the mayoralty of St Albans. In London he mixed with property developers and financiers. A familiar figure at court, Guy was appointed cup bearer to Catherine of Braganza before entering the king's household as first a groom of the bedchamber, then secretary to the Treasury. Through his mastery of administration, heavily involved in shady dealings, he turned his post into a position of personal power and influence.

Financed by Treasury pickings, Guy rebuilt Tring Manor (now Tring School) to designs by Sir Christopher Wren. He also built a house in the grounds for Charles II's favourite mistress, Nell Gwynne.

*Rye House Plot*

In 1683, followers of Cromwell, republicans, anti-monarchists and anti-papists planned to get rid of closet Roman Catholic Charles II and his out-of-the-closet Catholic brother, James. Richard Rumbold of Rye House and the Earl of Essex of Cassiobury openly declared their hatred of the brothers. There were many plans to kill them, but The Rye House Plot was chosen as the most likely to succeed. The narrow lane outside the castle was to be blocked by an overturned cart, a common enough sight. One hundred armed men in the grounds would shoot the brothers and finish them off with a sword.

The planned date for the brothers' return journey from Newmarket was 1 April but on 22 March a fire burnt down half the town. Charles and James helped with fire-fighting before returning a week earlier than planned to London.

Rumbold was executed. Arthur, Earl of Essex, Lord Lieutenant of Hertfordshire was arrested at home in Cassiobury, then taken to the Tower where he committed suicide. Lesser plotters were hanged outside Rye House Inn opposite the castle.

Conspiracy theorists said there was no plot, it was dreamed up by Charles and James to get rid of the most dangerous of their enemies in one fell swoop. The brothers knew full well that Richard Rumbold had stood cheering under the scaffold as their father died a gruesome death.

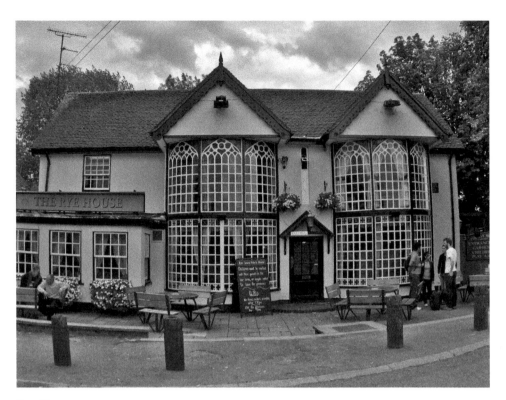

*Rye House*

Rye House was there in 1443 when Sir Andrew Ogard was granted a licence to 'impark and fortify the Maner of Rye'. The moated castle was built in 1583. Its gatehouse, said to be the oldest brick building in the county, has a permanent exhibition of the Plot.

When James II was deposed, Guy was dismissed from the Treasury for mismanagement of secret service funds (embezzlement), but, after he invited William III (William of Orange) to stay with him at Tring he was reappointed. However, his continued use of bribery and misuse of secret service funds did for him when it was discovered he used them to repair the town hall in his Yorkshire constituency. When he was exposed for giving hush money to MPs his enemies launched an inquiry into government corruption. Guy was found guilty of accepting bribes and put in the Tower.

On his release he became a close friend of Robert Harley, Lord Oxford, Secretary of State, spymaster general to William and Mary. As Harley had him on his payroll, Henry Guy probably had dealings with Daniel Defoe.

# CHAPTER 11

# DANIEL DEFOE

## THE INDEFATIGABLE MR FOE

We all know that Daniel Defoe invented the most famous footprint in the world in his book *Robinson Crusoe* but how many know that he was a secret agent?

What, exactly, was he doing when he roamed around Hertfordshire? He was not all he seemed, that's for sure. He worked for the government undercover as a ship builder, wool merchant and fish merchant. An important figure within the secret service, he spied for William and Mary and then for Mary's sister, Queen Anne.

When he was first recruited, his cover was as accountant to the Commissioners of Glass Duty. This is a man who went through his wife's huge dowry four times over and was declared bankrupt to the tune of £17,000. In fact, he was declared bankrupt twice.

When Defoe was sixty-four, Robert Harley, Lord Oxford, Secretary of State, commissioned him to compile a study of British political life by travelling through Britain under assumed names and reporting back to him.

A delighted Defoe tells Harley he plans to gather:

1. A perfect list of all the gentry and family of rank in England, their residences, characters and political interests.
2. Information on all the clergy in England, their benefice, character and morals and the like.
3. Information on all the leading men in the cities and boroughs with the parties they support.

When he wrote to Harley he used the pseudonym Goldsmith. When he reported in person, it was cloak and dagger stuff at the dead of night in secret via the tradesman's entrance. He told him about his forthcoming visit to East Anglia, 'which I fully believe may be the foundation of such an intelligence as never was in England'.

He wrote about his perambulations in *Tour Thro' The Whole Island of Great Britain*. In it, he mentions places all over Hertfordshire including Hitchin, Barley, Cassiobury, Baldock, Hatfield, Hemel and Tring.

He said the roads between South Mimms and St Albans were very well mended but The Great North Road at Stevenage was full of potholes. We know he was snooping in Hitchin because he wrote about the huge number of carriages bringing wheat into Hitchin Market. He wrote about the malt houses of Ware and Royston, commenting that the barley for them was grown at Ely.

Staying in Royston he reported back to Harley that 'The Gentleman of Royston Club settle all the affairs of the county… There is a monthly meeting of the gentlemen of all the neighbourhood the 1st Thursday in every month… They… have built a large handsome square room well wainscotted and painted and hung with the pictures of Charles I, Charles II, King James, King William at full length all very well painted on good frames 10 or 12 foot high…'.

The room he described in detail was built especially for the Royston Club at the Red Lion in Royston. True to our British tradition of erasing our astonishing heritage, the Red Lion was demolished. It's said that the famous room was taken down and re-erected as Assembly Rooms at the rear of the Bull Inn (now Bull Hotel) in the early 1800s. Surely what's there today cannot be what's left of the same room? It resembles a scout hut built by miscreants on community service.

As Defoe was making observations like, 'I was surprised at the beauty of… a planted garden [Bushey Heath]… one grand parterre', he was all the time reporting on the political temperature of the county. We know this because 200 years later, in 1897, among the Duke of Portland papers, was found a letter to Robert Harley from Defoe. 'That part of the country (Hertfordshire) adjoining Beds and Bucks is Whiggism and full of Dissenters. That part adjoining Huntingdon Cambridge and Essex is entirely Church and all of it of the High sort.'

He was proud of being in 'a special service… in which I had to run as much risk of my life as a grenadier'. Among the names he used were Alexander Goldsmith and Claude Guilot. A huge admirer of master spy Sir Francis Walsingham who was, he said, the 'greatest master of intelligence…' Defoe dreamed of following his hero, controlling a vast network of agents at home and abroad.

The father of the modern novel and modern journalism tried just about everything in his long life. Although never out of debt, despite being pilloried and imprisoned six times, he was appointed manager of The Royal Lottery.

He started a business importing wine and brandy from Spain, tobacco from America and exporting hosiery. He enlisted in the William of Orange army and imported civet cats from which he extracted musk from a sac above the anus and used it as a base for perfume; it didn't catch on.

A Dissenter, he had no time for the Church of England but neither did he want James II, a Roman Catholic, and the Pope, running Britain (he said Catholic countries were backward), so supported William and Mary, the daughter of James II.

*Assembly Rooms: The Bull Inn, Royston*

When he published *The True Born Englishman*, a satire on xenophobia (England was not enamoured of William of Orange, a foreigner) the queen, naturally, warmed to Foe. When he wrote, tongue in cheek, *The Shortest Way with Dissenters* (don't suppress them, hang them), Mary, staunch Church of England, was again delighted — until she was told Defoe was himself a Dissenter and that the book was a spoof.

A warrant was put out for his arrest and posters put up all over London, 'WANTED; Middle sized... spare... brown complexion... dark brown hair... but wears a wig... hooked nose, sharp chin, grey eyes and a large mole near his mouth.'

He was sent to the pillory where his adoring public pelted him not with rotten eggs but with flowers. In prison he wrote *Hymn to the Pillory*, added the fashionable 'De' to his name and launched *The Review*, his own newspaper. In it he attacked hypocrisy, double standards, misuse of privilege, abuse of power and campaigned for better treatment of women, the poor and the insane.

Robert Harley got him a royal pardon and hired him as a secret service agent at £400 p.a. Harley's cousin just happened to be Abigail Hill aka Mrs Masham, Queen Anne's intimate confidante; some sources say *very* intimate.

Defoe outlined his plans for an improved secret service, including intelligence gathering abroad with Counter Intelligence in the UK (MI6/MI5) advocating a police state with neighbours spying on neighbours along the lines of John Thurloe under Cromwell. He

planned for agents to be ordinary citizens unknown to other agents. He studied spies such as Cardinal Richelieu, Thomas Cromwell and Francis Walsingham.

In 1706, Harley sent him to Scotland to report back on the controversial Act of Union. When Defoe wrote a series of pamphlets for Harley attacking political opposition, the Whigs took Defoe to court, which resulted in yet another prison sentence. Harley was dismissed from government. When he returned to office, he got Defoe released with a royal pardon. Another time, imprisoned for libel, he was freed on the orders of Lord Townsend, Secretary of State. Defoe resumed his spying during the Jacobite Rebellion. He died in poverty, hiding from his many creditors in a Clerkenwell bedsit.

# CHAPTER 12

# RICHARD BURTON

## A Victorian Explorer with a Taste for Pornography

Richard Burton, the spy, not the actor, was baptised in Elstree Church and brought up in Barham House (renamed Boreham, then Hillside), Elstree. If things had gone the way he thought they should, maybe he would have died there too. His brother Edward, born at Barham House, was also baptised in Elstree Church.

His rich maternal grandfather, Squire Richard Baker of Barham House, had three daughters. One, Martha, Richard's mother, married Joseph Burton. Given a huge dowry, Joseph, a parasite, lived off it. He was not so successful when she inherited £30,000 in her father's will. The money was released piecemeal so that he could not gamble it away or spend it on prostitutes.

Squire Baker adored Martha's son Richard — named after him — and appointed him his heir. Richard Burton's first memory was of being in Barham House being brought down after dinner, fussed over and given white currants. An infant phenomenon, he could speak Latin and Greek aged four.

Richard was cheated out of his legacy because of his mother's misplaced loyalty. Martha persuaded her father to leave his estate to his son by his first marriage, her half-brother, who she adored. He reluctantly agreed, then changed his mind but died before he could change the will back again.

As Barham House was worth £80,000 (£5 million), which her brother gambled away within two years, Burton never forgave his mother.

Expelled from Oxford, he became an officer in the Bombay Native Infantry, an explorer, translator and publisher of erotica. One of Europe's great linguists, Burton spoke twenty-five languages. He knew more about Africa than any man in Britain, including Livingstone, Stanley and Speke. He wrote forty-three volumes about his explorations.

Fascinated with all forms of sexual deviation, his nickname was 'Ruffian Dick'. A Victorian James Bond, he was a genuine English eccentric whose achievements were superhuman.

When Sind in India fell under British rule, at twenty-four, a lieutenant in the East India Company, Burton was recruited by C-in-C, Sir Charles Napier, to provide intelligence

*Elstree Church*

reports. Unaware they were for homosexuals, he instructed Burton to investigate the brothels frequented by the British Army. Refusing to rely on intelligence via paid agents, as he was fluent in the dialect, Burton disguised himself as a local and opened a shop in Karachi. His detailed, explicit report resulted in closure of the brothels. It also ended his career. A shocked Napier, instead of sending it to London, hid it at the back of his safe. He did not mention Burton in his memoirs.

Napier's successor hated Burton and was determined to get rid of him. Clearing out the safe, he found the report. Not only did he tell his superior that it was written from Burton's first-hand knowledge of the brothels, accusing him of debauchery, but he ended Burton's army career.

Burton then joined an expedition with John Speke to discover the source of the Nile. Crossing Somalia they were attacked and forced to return home. The Royal Geographical Society funded their next expedition. By the time they arrived at Lake Tanganyika, Speke was almost blind and Burton was unable to walk. Speke somehow managed to push on alone and discovered Lake Victoria, the source of the Nile. When a devastated Burton disagreed with his findings, they became estranged. Their dispute only ended with Speke's suicide in 1864. Burton said Speke committed suicide before he could be exposed regarding his misleading statements about the source of the Nile.

Burton's next move was to the Foreign Office as consul in Fernando Po (off the coast of West Africa), then Brazil, and finally, Damascus. Robert Cecil, Lord Salisbury, recommended that Burton be made Knight Commander of St Michael and St George for services to the crown.

In 1883, he translated *Kama Sutra; The Perfumed Garden* and *Arabian Nights*. Threatened with prosecution under the Obscene Publications Act, the sexually explicit *Arabian Nights* was published by private subscription. A huge financial success, it made him world famous. *To The Holy Shrines* (recently reissued) tells how, to get to the forbidden city of Mecca, Burton disguised himself as Al-Haj (the pilgrim) Abdullah. He drew plans of the Great Mosque and its sacred inner shrine, the Kaaba.

When Burton died, Isabel, his loyal, devoted wife, a staunch Roman Catholic, burnt all his papers including the original manuscript in Arabic of *The Perfumed Garden* he had been working on for fourteen years. She built his mausoleum in the shape of an Arab tent and paid for a stained glass memorial window in the Roman Catholic Church of St Mary Magdalen, Mortlake.

# CHAPTER 13

# WALSIN ESTERHAZY

## The Dreyfus Affair

Outside France, how many today remember The Dreyfus Affair? Harpenden does because Charles Walsin Ferdinand Esterhazy, the traitor and spy responsible for The Dreyfus Affair is buried in St Nicholas churchyard, Harpenden. The inscription, now almost indecipherable, on the small, pitted gravestone put up by his mistress says, 'In Loving Memory Count de Voilemont 1849-1923'. His name was not Voilemont. Neither was he a Count.

Considering he died a rich man and presuming his mistress inherited, she did not spend much money on the memorial. Modest is kind, cheap is more accurate.

The Dreyfus Affair, the biggest cover-up in French history, lasted twelve years. It took an Act of Parliament to clear the Dreyfus name. The trial of the twentieth century attracted worldwide media attention.

Employed to translate German for the French War Ministry, Esterhazy received a generous monthly payment from the Germans for selling them secret military information. He told them he got his information from the chief of Intelligence, Major Henry, his friend in military counter-intelligence.

Austro-Hungarian by birth and naturalised French, Esterhazy, a veteran of the French Foreign Legion, joined the regular French army and rose to major. A compulsive gambler, he spied for money. A mole, an office cleaner, was responsible for emptying the wastepaper basket of the military attaché at the German embassy in Paris and passed the contents on to French military security. Torn documents proved that secrets were being betrayed to the Germans by an unidentified French officer. Major Henry, recognising his friend Esterhazy's writing, erased his name from the list of suspects, not daring to expose him in case he was seen as an accomplice. The finger of suspicion turned to Captain Alfred Dreyfus.

Dreyfus, hard working and conscientious, a rich Jew in notoriously anti-Semitic France, then and now, was a scapegoat. At his secret court martial in 1894, a devastated Dreyfus insisted he was innocent. With no evidence to go on, the court was about to acquit him

*Walsin Esterhazy grave*

when Commander Henry handed a packet to the judges. It contained papers referring to the traitor in the French War Office as 'that dirty dog D'.

Dreyfus was sentenced to life imprisonment on the hellhole of Devil's Island, stripped of his commission and ritually humiliated at a formal parade where he was booed and hissed as his sabre was broken in front of him. Convicts sent to French Guiana in South America suffered a living death. Devil's Island was notorious for its inhumane conditions.

His brother, Mathieu Dreyfus, started a campaign to clear his name supported by the novelist Emile Zola and the politician Georges Clemenceau. With Dreyfus on Devil's Island, discovering that French military secrets were still being passed to the Germans, investigating Officer Colonel Georges Picquart found evidence that Major Charles Walsin Ferdinand Esterhazy and Commander Henry had forged the documents in the packet handed to the court. Picquart received a sudden posting to Tunisia. No attempt was made to release Dreyfus.

An undeterred Picquart helped bring about a court martial for Esterhazy, but his fellow officers acquitted him. The French novelist Emile Zola then published 'J'Accuse', his famous open letter in Clemenceau's newspaper *L'Aurore* stating that the army knowingly sent an innocent man to prison to protect a guilty one. He condemned the court martial

which acquitted Esterhazy saying Dreyfus was set up to protect Esterhazy, the real traitor. This resulted in a libel case, which Zola lost. He was fined and given a year's imprisonment, which he avoided by moving to England.

Dreyfus, brought back from Devil's Island, appeared before a new court martial. The court again found Dreyfus guilty, but, bizarrely, pardoned him. In 1898, with the whole world watching and reporting on it, a new trial was granted, this time in a civilian court of appeal. Dreyfus was found not guilty. All previous convictions were reversed, and he was reinstated by a Parliamentary bill.

Commander Henry confessed to his part in the lie before committing suicide. Esterhazy escaped to England and settled in Harpenden. Here, Esterhazy and his mistress called themselves Mr and Mrs Fitzgerald and rented rooms from Mr and Mrs Humphrey in 'Maisonette', Tennyson Road before moving into 'The Elms', Station Road.

During the First World War, Esterhazy paid the rent by writing and selling anti-British articles to newspapers under the name Fitzgerald. He was sixty-two, corpulent and always wore a long black cloak. 'Mrs' Fitzgerald, thirty, kept spaniels, played the piano and bought sheet music from Billingham's music shop. Esterhazy, now calling himself Count Voilemont, bought 'Holmleigh' in Milton Road, a huge house in its own grounds with stables, and hired servants. Waverley Flour Mills were nearby. Throughout the war, Esterhazy wrote anti-British propaganda for German newspapers using the pen name Waverley. MI5 managed to track him down and kept him under surveillance.

Émile Zola died of carbon monoxide poisoning in 1902 at his home in Paris in suspicious circumstances. His chimney had been sealed. Esterhazy admitted his guilt before he died. After his death, when his true identity was revealed, the rumours started; neighbours had heard Morse code coming from his house; his walking stick was hollow and concealed secret documents; when the handle was unscrewed a tiny light-bulb was found in the silver mounting.

In 1923, Dreyfus, on active service in the First World War, was promoted to Lieutenant Colonel. After the war, he was awarded the Legion of Honour. He died in Paris in 1935.

# CHAPTER 14

# THE GRAND DUKE MICHAEL ROMANOV

## THE LAST TSAR OF RUSSIA

The man who was, for a few hours, the last Tsar of Russia, once lived in Knebworth House.

The Prince Regent, His Imperial Highness, The Grand Duke Michael Romanov, brother of Tsar Nicholas II, was tailed by Russian agents, but gave them the slip and married his lover, a commoner, in secret. Formally exiled by his brother, he asked George V permission to settle in England. Granted, the couple moved into Knebworth House.

In 1907, Grand Duke Michael (Misha) met Natalia (Natasha) Wulfert, the love of his life. Not only was she a commoner (her father was a solicitor), she was twice married. Her first husband, with whom she had a daughter, Natalia (Tata), divorced her for having an affair with the officer who became her second husband.

When her second husband discovered Natasha was having an affair with Michael, he challenged the Grand Duke to a duel. As this was treason he was forced to resign his commission. Natasha gave birth to George, Michael's son, four months before her divorce came through.

When the Tsar refused Michael permission to marry Natasha, they married in secret in Vienna. The Tsar, following Imperial law, stripped his brother of the Regency and exiled him. Although he could have lived anywhere in Europe, Michael chose England, a country he loved (English was his language of choice). His first cousin was after all King George V and London was full of Russian émigrés. Another cousin, Grand Duke Michael Mikhailovich, also banished from Russia for marrying a commoner, lived with his morganatic wife at Kenwood House, Hampstead.

By September 1913 Michael and Natasha were happily ensconced in Lord Lytton's grand Knebworth House with its oak banqueting hall, picture gallery, state drawing room, library and four-poster beds. The lease included stable lads, housemaids, gardeners, cooks, a butler and fourteen footmen in powdered wigs and knee breeches.

Natasha, who held Open House for the stars of Ballet Russes and the Russian Opera, then taking London by storm, was in her element. She said that her rôle as mistress of

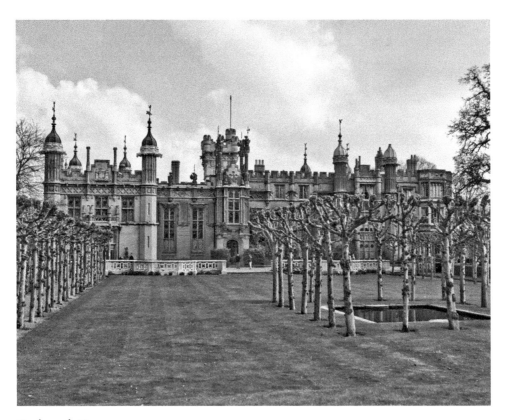

*Knebworth House*

Knebworth was the happiest time of her life. Her daughter by her first husband, Tata, ten, and her son, George, three, loved it there. Tata had her own footman, lady's maid, governess and pony.

On 1 August 1914, Germany declared war on Russia. On Friday 14 August, the staff of Knebworth House saw Prince Michael and his family off at Knebworth station. He was going home to fight for his country.

Three years later, his brother was forced to abdicate and appoint Michael Tsar.

Michael was murdered by the Bolsheviks in 1918. His son, George, died in 1931 in a car accident when he was twenty-one. George celebrated finishing his final examinations at the Sorbonne by driving to the south of France with a friend. On the way, their car skidded and crashed into a tree. They both died. Natasha died of cancer in poverty in a Parisian charity hospital in 1952 at the age of seventy-one. Tata, while still at school, secretly married Val Gielgud, elder brother of the actor John Gielgud, in 1921. She died in Essex in 1969.

# CHAPTER 15

# T. E. LAWRENCE

## T. E. SHAW OF AYOT

Lawrence of Arabia preferred to be known as T. E. Shaw. The surrogate son of Charlotte and George Bernard Shaw of Shaw Corner, Ayot St Lawrence, changed his name to Shaw by deed poll in 1927. At home in Clouds Hill, Dorset, he was always known as Shaw; his real name, however, was not Lawrence or Shaw, it was Chapman.

Shaw Corner was Lawrence of Arabia's refuge for the last thirteen years of his life. The furniture from his bedroom is in storage, but the room itself, used as an office with no trace left of its world-famous hero, is not open to the public — shame on The National Trust. Charlotte, his most loyal fan, would not be pleased.

It was George Bernard Shaw who bought Lawrence the Brough Superior motorbike he died on. He said, in retrospect, it was like handing a pistol to a would-be suicide. Lawrence met Charlotte Shaw when he asked Shaw for literary advice about his autobiography, *The Seven Pillars of Wisdom*, dubbed by critics as 'The Seven Pillars of Boredom'. It went through three drafts. He left the first one at Reading Station. In the preface he thanked Mr and Mrs Bernard Shaw 'for countless suggestions of great value and diversity: and for all the present semicolons'. Because it was written as a result of his war service, he refused to make money from it.

In Charlotte, sixty-five, he had a soul mate. From her, Lawrence enjoyed the maternal affection he rejected from his own mother. Like Shaw and Catherine, Lawrence was Anglo-Irish.

When Lawrence asked Shaw to cast his eye over the first draft of *The Seven Pillars of Wisdom*, Shaw was busy, so Charlotte read it. She wrote to Lawrence to say that she had devoured it cover to cover and to her husband's annoyance insisted on reading bits out to him. Despite the book having parts deemed shocking she advised him not to cut them out. Shaw chided him on his poor punctuation. Charlotte did for Lawrence what she did for Shaw: she inspired and encouraged him.

Confidences were exchanged in 600 letters. Shaw, when Charlotte died in 1943, discovered facts about her he had not known during their forty years together. Despite

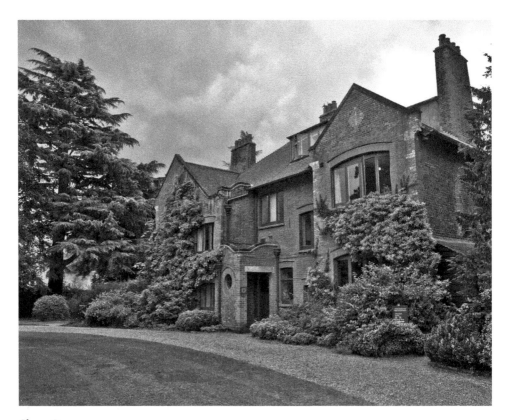

*Shaw Corner*

friends and acquaintances assuming it was Shaw who insisted on the non-consummation of their marriage, Charlotte told Lawrence it was her ruling.

Lawrence, for the first time in many years optimistic about his future, spent his last years testing, supervising and designing high-speed power motorboats at Bridlington, Dorset. When he moved into Clouds Hill, Bovington, a tiny three-roomed gamekeeper's cottage between Dorchester and Wareham, a sleeping bag embroidered with the word 'tuum' was provided for guests such as Shaw, E. M. Forster, Robert Graves and Siegfried Sassoon. Lawrence slept in the other one embroidered 'meum'.

George Bernard Shaw, who never quite believed Lawrence's version of events during the First World War, wrote a play about him called *Too True to be Good*. In it Lawrence is Private Napoleon Alexander Trotsky Meek who runs the company while his colonel dabbles in watercolours. Meek repeatedly enlists with the army, quitting whenever he is offered a promotion. In Meek's one-man-army attack, the enemy is frightened off by fireworks. Terence Rattigan also wrote a play about him, *Ross*, and David Lean made the film *Lawrence of Arabia*.

Lawrence worked as a British Military agent undercover on archaeological digs. Trying to sway the Middle East in Britain's favour, he organised the Arab revolt against the Turks.

His friend and mentor, Sir Hugh Lord Trenchard of Hertfordshire, said he was a flawed genius and quite unbalanced.

Thomas Edward Lawrence, known in the family as 'Ned', was the second of five illegitimate sons born to Sarah Junner and Sir Thomas Chapman, 7th Baronet of Westmeath, Ireland. Thomas had left his wife, Edith, and their four daughters to set up home with Sarah Junner, his children's governess, the daughter of a Durham engineer. They lived in Oxford in secret as Mr and Mrs Lawrence.

Ned went to Jesus College, Oxford to study archaeology and architecture. He walked through Syria, Palestine and Turkey. After gaining a first-class degree he was awarded a travel scholarship by Magdalen College.

He joined archaeological digs under Flinders Petrie on the banks of the Euphrates. He learned Arabic, ate Arab food, wore Arab clothes and fell in love with a fifteen-year-old Arab boy, Salim Ahmed, whom he called Dahoum. He even took him home on holiday. They were inseparable until Dahoum disappeared. He was found in 1918 dying of typhoid.

The Ottoman Empire declared war on a Britain which wanted Turkey because of its oil and land passage to India. Lawrence was recruited by British Military Intelligence. As the only British officer on the Arab front he was sent to negotiate with Arab leaders. He fought with Arab irregular troops under the command of Prince Faisal against the Ottoman Empire.

He was promoted to major, then lieutenant colonel DSO. He refused to be made a knight commander; King George V said, 'He left me there with the box in my hand'. In 1922, he joined the RAF as John Ross. The recruiting officer was none other than W. E. Johns of Hertford who became famous for his eponymous hero, Biggles. When his real identity was discovered, Lawrence was discharged.

Lawrence was friendly with spies John Buchan and Elizabeth Bowen. When Buchan wrote to him he always addressed him as 'My dear Shaw'. On Friday 26 April 1935, Lawrence paid one of his surprise visits to the Buchans at Elsfield Manor in the Cotswolds. A few weeks later he was dead.

In February 1935, Lawrence retired three months before his death. Almost home, on his beloved Brough Superior motorbike he swerved to avoid cyclists and was thrown off. He was unconscious for five days and died in Bovington Camp Hospital. His simple funeral can be seen online at British Pathé News. His bust is in St Paul's Cathedral Crypt.

In 2000, members of the Brough Superior Owners Club, riding valuable museum pieces made the 150-mile journey from Clouds Hill in Dorset to Shaw Corner at Ayot St Lawrence, a trip Lawrence had made hundreds of times on his own Brough Superior. His bike, GW 2275, is on display at the Imperial War Museum.

# CHAPTER 16

# COMPTON MACKENZIE

## THE SPY WHO SPILLED THE BEANS

Compton Mackenzie, if he's remembered at all, is remembered for his book *Whisky Galore*, which, in 1947, was turned into a successful film and adapted for *Monarch of the Glen* (TV Series). His sister was the actress Fay Compton.

Mackenzie once lived in the rectory of High Cross church. Coached by Revd Arnold Overton for the Oxford entrance exam, his memoirs tell us he was very happy there with three other students. No shrinking violet, he wrote ten volumes of autobiography, *My Life and Times*.

Mrs Overton, in her thirties, tall and good-looking, hated what Mackenzie called 'bullshit'. A book reviewer for *The Guardian*, she mothered her husband's charges, who called her mum. The Overton's had two boys age six and seven. Later, Mackenzie was godfather to a third. The young Mackenzie's prize possession was his green Raleigh bike on which he often rode home to Earls Court, a distance of twenty-five miles. He joined the Ware Company 1st Volunteers, forerunners of the Territorial Army, a crack battalion which drilled three times a week. He loved it, especially the grand uniform which cost his father a fortune £100 (£6,000).

In 1932, in his office opposite St James's Park tube station on the morning of 27 October, Admiral Sir Hugh Sinclair, chief of MI6, was furious as he read a file marked Top Secret — a detailed analysis of a book by Mackenzie.

*Greek Memories* was an autobiographical work about his time spent as an intelligence officer. Had it been published it would have lifted the lid off MI6, which few knew existed. As late as 1951, when the traitor Kim Philby was asked to resign [*sic*] it was from the Foreign Office; MI6 did not officially exist.

Within the hour, Vernon Kell, director general of MI5, had the book banned and proceedings against Mackenzie instituted under the Official Secrets Act. *Greek Memories*, a handbook on how the Secret Service worked, was a revelation. Mackenzie referred to 'scores of under-employed generals surrounded by a dense cloud of intelligence officers sleuthing each other'. He also revealed that MI5 had a 'blacklist'.

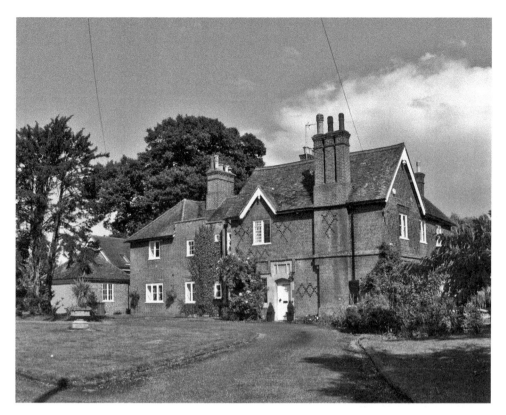

*The Old Rectory: High Cross*

He explained in detail how the Secret Service was 'attached to the War Office' although it got its funding from the Foreign Office, how heads of station abroad functioned undercover of passport control officers through British Legations, and how agents communicated with each other using a 'dictionary code'. He also revealed the identities of heads of station, including Sir William Wiseman, head of station in America.

He disclosed that Whitehall Department MII was the Secret Intelligence Service (SIS, now MI6) and that its head was called C. C. — the one-legged Sir Mansfield Cumming who Mackenzie held in great esteem — describing how he met him for the first time at the Service HQ on the top floor of Whitehall Court. He tells how, early in the war, Cumming's car hit a tree trapping him in the wreckage. Unable to free his smashed leg, Cumming cut it off and crawled from the wreck.

Mackenzie also gives a detailed account of how Cumming offered him the job of deputy head of the Secret Service. 'I'll go through the war and I'll stick on for a couple of years after it's over, and when I go you'll step into my place.' Mackenzie turned the job down, saying as soon as the war was over he wanted to get back to his 'writing job'. By the time of their next meeting, Cumming said that resignations had been threatened if Mackenzie was appointed.

When Mackenzie appeared at the Old Bailey he laughed often. Among the intelligence officers the prosecution claimed had been endangered by his book was Captain Christmas. Mackenzie pointed out that he died in 1922. Another on the prosecution's list was Major C. E. Heathcote-Smith, who had already referred to his wartime intelligence work in *Who's Who*. Mackenzie pleaded guilty to breaching the Official Secrets Act was fined £100 (£15,000) and ordered to pay costs.

Although the book was withdrawn, there is a copy in the Bodleian Library at Oxford listed under suppressed books. An expurgated edition was published in 1939.

Mackenzie took revenge on MI6 with *Water on the Brain*. His Directorate of Extraordinary Intelligence MQ99 (E), C. was satirised as N., Sir Vernon Kell as P. Mackenzie includes a few genuine facts — such as the chief of the service always writes in green ink. At the story's end, the location of SIS HQ is revealed. The building becomes an asylum for 'the servants of bureaucracy who have been driven mad in the service of the country'.

MI5 was suspicious when Mackenzie was spotted talking to Sir Oswald Mosley, who had just given a speech in a London club saying that '… Scottish people should be allowed to manage their own affairs'. An MI5 mole in the BBC, Frost-Major, told Anthony Blunt — ironically, as it turned out a Russian spy — in confidence about a conversation with Mackenzie and a *Daily Telegraph* journalist in which Mackenzie 'complained bitterly of the inefficiency of MI5 and said that Kell [General Sir Vernon Kell, the first head of MI5] and his staff were incompetent'.

Frost-Major said that Mackenzie waited 'for many years to get his own back at MI5' and was busy accumulating evidence for left-wing Labour MP Aneurin Bevan to produce in the House of Commons.

Recently released two-volume MI5 documents reveal Mackenzie serving on the Gallipoli front and his recruitment into the Secret Service in 1915 as director, Aegean Intelligence Service. According to the files, Mackenzie was overheard by an agent at a cocktail party declaring that 'the IRA were doing exactly the right thing in perpetrating their various outrages, and they should continue to do so until they won their demands'.

Mackenzie deeply resented his prosecution and the fact that MI5 spied on him until he died. He can be seen online at British Pathé News.

# CHAPTER 17

# JOHN BUCHAN

## THE GARDEN CITY MYSTERY

You do wonder if John Buchan would be miffed to be remembered as the man who wrote *The Thirty-Nine Steps* as opposed to Baron Tweedsmuir, governor general of Canada, but such is the power of film and, of course, the enduring allure of Alfred Hitchcock.

The local history archives of Letchworth Garden City library hold two intriguing index cards:

1. Buchan, John, first Baron Tweedsmuir stayed at Derenda Cottage, Willian Way, Letchworth, while convalescing *c.* 1915. Letchworth appears disguised as The Garden City of Biggleswick in 'Mr Standfast' published 1919.
2. Trotter, Captain, J. Stewart, Derenda Cottage, Willian Way corner of Barrington Road (later called Rest Harrow). John Buchan stayed with him at this house while convalescing *c.* 1915.

Intriguing, because no one outside the town is aware of the visit. Letchworth is not mentioned anywhere in the Buchan archives. Buchan doesn't mention it in *Memory Hold the Door*. Nor does his wife in *John Buchan by his Wife and Friends*. Andrew Lownie did not come across any mention of Letchworth while researching his biography *John Buchan: The Presbyterian Cavalier* even though he had access to private papers not used before. Neither did the National Library of Scotland, the University of Edinburgh or the University of Kingston, Ontario, which holds the bulk of Buchan papers. Kingston contacted a Mr Samuel Bell, said to be a world authority on Buchan.

The John Buchan Society says the visit is not recorded anywhere. Indeed, it didn't know that Buchan's garden city of Biggleswick is Letchworth. Their website says, 'The scene changes purposefully through London, *a fictional Home Counties location*, Glasgow, the Highlands and Islands.'

*Derenda Cottage*

Buchan's son, Lord Tweedsmuir, wrote, 'I'm sorry to say I have no knowledge of Captain Trotter or Derenda Cottage. Nor is it mentioned in any of his papers.'

Gardening expert Ursula Buchan, John Buchan's granddaughter, on a visit to Harkness Nursery, Letchworth, was shown Rest Harrow in Willian Way, the house where the library index cards say her grandfather stayed. As it turned out, she was shown the wrong house — Derenda Cottage is 42 Willian Way, almost exactly opposite Rest Harrow.

Dr Janet Adam Smith, Buchan's first serious biographer and a close family friend, by default offers the strongest case for Buchan being in Letchworth. She said, 'The background [in his novels] remains firmly within his experience, except, possibly, for the garden city of Biggleswick with its quacks and cranks for which I can find no parallel in his life.' She clearly never knew that Buchan might have had links with Letchworth.

Founded in 1903, Letchworth attracted an eclectic mix of Quakers, socialist idealists, free spirits, bohemians, painters, potters and poets, becoming the butt of satirical cartoons in the national newspapers. As the town's reputation grew, so did its quota of Esperantists, wearers of togas, smocks and sandals with long hair and beards, avant-garde vegetarians, animal rights activists (they tried to free the lions from a visiting circus) and numerous cult religions (Theosophy, Christian Scientists, Liberal Catholics,

Plymouth Brethren, Spiritualists, etc.). Annie Besant, leader of the Theosophists, laid the foundation stone for St Christopher Theosophical Trust School (site now occupied by St Francis College), one of the most progressive schools in Britain. A Fabian was appointed the first headteacher. A local woman made the national news by refusing to pay her rates until she was given the vote. In the Annie Lawrence Cloisters, a residential summer school, guests wore monks' habits, wrote poetry, slept in hammocks, swam in the pool to greet the dawn and ate al fresco.

It turned out that Mr Samuel Bell did not know Buchan's Garden City as depicted in *Mr Standfast* existed. He said there was no mention of Letchworth in the 500 books or countless letters and newspaper clippings he had studied by and about Buchan.

It's a mystery as gripping as any confronted by Buchan's alter ego, Richard Hannay. Librarians do not write out index cards willy nilly. Who wrote them? Kenneth Johnson, of the library staff, now retired, author of *The Book of Letchworth*. Mr Johnson was told of Buchan's visit by Donald Ross of 13 Willian Way. Ross worked for Dents from 1939 to 1966 (interrupted by war service) and was editorial manager for the Everyman series from 1967 to 1973. Ross was told by Charles Purdom, the Dent author, father of the film star Edmund Purdom, famous for his starring role in *The Student Prince*.

Purdom was a major player in the garden city. In March 1904, he became estate office manager, Letchworth's first resident and guided the town's development until 1921 when he moved to take up similar work in the newly created Welwyn Garden City.

It seems, therefore, that it was Charles Purdom who said Buchan was in Letchworth in 1915. Purdom was very responsible. He would not have said Buchan was there if he wasn't. He served on the Western Front in France when Buchan was there, first as special correspondent for *The Times* and then as an army intelligence officer. Did they meet? Did they know each other? He also said there were eyewitnesses to Buchan's visit. Once seen never forgotten, Buchan's appearance was distinctive: he had a facial scar, the result of a childhood accident.

Historian Dr Robert Beevers, in *The Garden City Utopia* also said that Buchan was '... one of the earliest of the temporary war-time residents' but, of course, he may, justifiably, have taken the index cards at face value. *Mr Standfast* is the third in a trilogy of books about the First World War along with *The Thirty-Nine Steps* and *Greenmantle*; all of these books were written with insider knowledge. *Mr Standfast* is named after a character invented by his hero, another JB, John Bunyan, in *The Pilgrim's Progress,* the world's most famous allegory, which Buchan read all his life. An allegory, of course, is where characters and happenings have hidden meanings. Buchan calls Chapter One of *Mr Standfast* 'The Wicket Gate', which is featured in *Pilgrim's Progress*.

Buchan said he never invented anything for his spy novels and threw nothing away regarding his life experiences. The garden city of Biggleswick as depicted in *Mr Standfast* is an accurate portrait of the town as it was in 1915, not a figment of his imagination. Anyone who knows Letchworth recognises it instantly in the first three chapters. When it

was published, residents identified the characters. When later the local Harkness nursery started breeding roses, they named one of their earliest 'Mr Standfast'.

In the story, Richard Hannay — like Buchan in real life — is recalled from the Western Front in France by British Intelligence. This in itself, given when it was written, was an astonishing thing to write. Until Compton Mackenzie spilled the beans in the 1930s about his espionage activities in *Greek Memories*, the government denied it had a secret service. 'Here I was,' said Hannay, 'still under forty'. Buchan was thirty-nine.

'I had the queerest interview with Bullivant and Macgillivray. They asked me first if I was willing to serve again in the old game.' Spying has always been referred to as 'The Great Game'. Buchan was an intelligence agent in South Africa.

Hannay: 'I spent one third of my journey looking out of the window of a first class carriage.' Buchan certainly travelled first class. He married into the English aristocracy and knew the king (George V).

Hannay is sent to Biggleswick Garden City, the scene of suspected espionage activity, to foil a plot by Count von Schwabing, a master of disguise, living under the name of Moxon Ivery. A key enemy agent, there to infiltrate groups of pacifists and conscientious objectors, he is the brains behind The Wild Birds, a sinister organisation. Buchan was very well aware that Letchworth was a focal point for pacifists and conscientious objectors.

Von Schwabing had to be destroyed. Vernon Kell was director of the Home Section of the Secret Service Bureau, with responsibility for investigating espionage, sabotage and subversion in Britain (MI5). His maxim was 'Identify the enemy; discover his activities and methods; neutralise him.' He founded his Important People Club to gather intelligence on Irish sympathisers, Communists, trade unionists and pacifists. He must have loved Letchworth. Hannay identifies Ivery, discovers his methods but fails to neutralise him — that would have been the end of the story. Moxon evades capture but Hannay tells Sir Walter Bullivant, head of British Intelligence — Buchan was head of British Intelligence — he would recognise von Schwabing again.

Using the alias Cornelius Brand, Hannay poses as a pacifist South African mining engineer although Hannay/Buchan said that the price his friends paid for their country 'didn't put me in love with pacifism'. Friends such as Peter Pienaar 'who joined the RFC when we got back from the Greenmantle [second Hannay novel] Affair'. Pienaar is said to be based on Buchan's close friend Bron Herbert who died in France, as did his adored brother Alastair, his bosom pal Tommy Nelson and Raymond Asquith from his Oxford student days.

On page 15 of *Mr Standfast*, Richard Hannay is told to 'spend next Thursday night as the guest of two maiden ladies called Wymondham'. Wymondham sounds very like Wymondley. Only someone who knew Letchworth well could know that two nearby villages Great Wymondley and Little Wymondley are known locally as The Wymondleys.

Hannay left Fosse Manor in the Cotswolds for Letchworth 'where pacifism is rife'; in real life, during the Great War, it certainly was. Was Fosse Manor, Checkendon Court, Oxfordshire, where he lived in 1915? The Fosse Way passes to the west of Checkendon.

In the book, John S. Blenkiron (echo of Ironside, fellow spy from Buchan's Boer War days?) tells Hannay, 'The brothers had a look at my duodenum... they sidetracked it and made a noo route for my nootrition'. This is precisely what happened to Buchan — in *Mr Standfast* he called chapter 3 'The Reflections of a Cured Dyspeptic'.

Hannay is sent to live among fifth columnists in Biggleswick. A fifth column is, of course, a subversive organisation and there were plenty in Letchworth. He takes rooms among 'gimcrack little arty houses' (how a derisive media and, indeed, John Betjeman much later referred to Letchworth architecture) and goes undercover to observe a network of traitors. During the First World War, Letchworth's conscientious objectors were branded as traitors.

Taking a 'fly' from the station in the 'backwater of Biggleswick Garden City' — Biggleswade and Ickleford are near Letchworth — Hannay lodges in the cottage of Tancred Jimson. Letchworth properties, even large houses, were, and are still, disingenuously called cottages. Derenda Cottage where Buchan is said to have stayed is, in fact, a detached house.

In Hannay's luggage is a set of English classics in a little flat backed series at 1s apiece. Among them is *Pilgrim's Progress*. J. M. Dent, Letchworth publisher of the Everyman series, 1s each, included *Pilgrim's Progress*. Mary Lamington instructs Hannay to learn *Pilgrim's Progress* by heart — as Buchan did in real life — because passages would be used between them in code.

Hannay is introduced to a character called Letchford. The manor house was called Lechford. He calls the town 'This odd settlement'; Letchworth was often referred to as such. The Skittles Inn — it had a skittles alley — is now called The Settlement.

Hannay, like Buchan, went on long walks. Is this how Buchan discovered The Wymondleys? He said nearby villages had pubs where he often had a pint of beer because 'Biggleswick... sold nothing but washy cider'. This was true. The garden city was 'dry', if residents fancied a pint, they went to The Fox in Willian not far from Derenda Cottage. The Skittles Inn sold Cydrax (non-alcoholic cider) but how did Buchan know? Did he visit?

When the Skittles Inn closed, the manager, Bill Furmston, went to work in The People's House, a temperance social club, a tall red brick building in Station Road (today it's an Employment Office). Attached is The People's Hall used then and now for meetings. Buchan/Hannay says, 'Near the station stood a red brick building called the Moot Hall ... used for lectures and debates...'

He said one old fellow (easily identified by Letchworth residents) talked about English folk songs and dances. He did indeed. Herbert Morrison (Peter Mandelson's grandfather) met his first wife at one such folk dance. A conscientious objector, Morrison worked for a local nursery run by J. J. Kidd, a fellow Socialist described as a firebrand. Not that he would have had to bear arms; he was blind in one eye.

The real meeting place in the garden city, Mrs Howard's Memorial Hall (speakers included G. B. Shaw and Rider Haggard) is of white stucco, not brick. When permission was refused to hold pacifist meetings there, did they move to The People's Hall? Hannay counted twenty-seven varieties of religious convictions. In fact, there were many more.

*The People's House: Letchworth Garden City*

Mary Lamington told Hannay: '… we are… hunting the most dangerous man in all the world…' Who, during the First World War, for Britain, was the most dangerous man in the world? Was it Lenin who vowed to bring down every European monarchy starting with the Tsar? Lenin's Bolshevik Party was, in effect, an intelligence agency. Britain's secret service, SIS, said Lenin was in league with Germany. Lenin's own people accused him of being a German spy when the Kaiser arranged a sealed train for his return to Russia. If Lenin allied himself with Germany, Britain's chances of winning the war were slim. Two million German extra troops would be freed up to fight Britain.

After the failed Russian revolution attempt in January 1905, when refugees fled Russia, Lenin was already living in London. With much sympathy for them in Letchworth, some ended up there. Charles Purdom said, 'Russian refugees found a temporary home in the town, including for a short time V. I. Lenin…' Given that Arthur C. Turner said Buchan was called home to work in Intelligence for six months, the link with Lenin would explain Buchan's presence in Letchworth. What is strange is that Purdom knew of Lenin. In 1905, Lenin was unknown to the general public in Britain and never used his real name.

Lenin made many visits to Britain, always under close surveillance. In 1907, he stayed in Letchworth as a guest of Rev Bruce Wallace and must have met Russian refugees. At 85

Norton Road in the cottage 'Oblomova' was Russian refugee Mrs Fanny Stepniak, widow of a Russian revolutionary who died in 1895. Mrs Stepniak died in 1945. Her husband's real name was Kravchinsky, author of *Underground Russia*. MI5 knew all about Sergei Kravchinsky aka Stepniak. He was head of The Society of Friends of Russian Freedom in London. Madame Stepniak is mentioned in *The Pageant in Letchworth 1903-1914* by A. W. Brunt as one of the early residents. Arthur W. Brunt, editor of the local paper, *The Citizen* (his brother was the reporter), was Chair of the local branch of the International Labour Party (ILP). It opposed imperialism and the Boer War and supported Ireland's demand for Home Rule. Churchill said 90 per cent of the government's time in the years leading up to the First World War was concentrated on Ulster, not Germany.

Apart from Intelligence Services not much was known about Lenin's secret wartime activities, yet, as early as 1922, Buchan was writing about the Bolsheviks in his novel *Huntingtower*. In 1935, in *The King's Grace*, he said, 'Outlaws long in exile were assisted by Germany to return to their native land, among them... Vladimir Ulianov, familiar to the world as Lenin'.

Why did Buchan send Hannay to Letchworth, then a fledgling community administered by Hitchin Rural District Council? He could have sent him anywhere. Because, during the First World War, Letchworth was under surveillance, viewed with deep suspicion by the establishment and openly accused in the national press of all kinds of underground anarchic skulduggery. A time comparable with America's 'reds under the beds', 200 local pacifists were jailed as Conscientious Objectors (conchies). *The Daily Mail* said Letchworth was a haven for Communists. Many objectors were sent, like Herbert Morrison, to work in Letchworth where strong Quaker links guaranteed they would receive sympathy and support.

In *Herbert Morrison — Portrait of a Politician*, Letchworth is said to have attracted socialists and anarchists. It was the centre of the underground for conscientious objectors on the run such as Morrisson's friend Frederic Osborn with whom he stayed. Ebenezer Howard, founder of the garden city, told Osborn how to dodge the authorities when he went into hiding.

The Letchworth branch of the Social Democratic Federation (SDF) attended Lenin's RSDLP Congress in Southgate Road Brotherhood Church in Islington and protested at the harassment of its delegates by the police. Letchworth also had a Brotherhood Church.

Aside from Letchworth, Buchan was familiar with Hertfordshire. As an Oxford undergraduate he spent holidays with his close friend Auberon (Bron) Herbert, Lord Cowper's nephew and heir, at Panshanger near Welwyn. Part of his estate was bought by the First Garden City Company in 1919, to establish Welwyn Garden City. Buchan was devastated when Bron was killed in action in 1917.

If Buchan was in Letchworth his family did not know. Why is not the visit recorded anywhere? His son said his father always kept part of himself private, inviolable. If he was in the garden city undercover, and it looks as if he was, it's perfectly plausible that he told no one. The facts add up.

## A Timeline to Show That Buchan Could Have Been in Letchworth in the Autumn of 1915

*1902: The Boer War. Buchan, private secretary to Lord Milner, British High Commissioner in South Africa, is one of his kindergarten of spies. Also, there is military spy and fellow Scot William Ironside (echoes of Blenkiron?) and Colonel James Trotter, Head, Secret Section 13, War Office. Trotter is not a common name. Was this Colonel James Trotter related in an way to the Captain James Trotter who Buchan was said to have stayed with in Letchworth?*

William Buchan (son) in *John Buchan, A Memoir* says, 'Once, when I was lunching with him at the Café Royal, he stopped mid-sentence to say; "Something's just come back to me. I used to interview people here, in an upstairs room, under the name of Captain Stewart".'

*1903: Buchan is appointed director of Thomas Nelson, publishers.*

Publishers know each other; he would certainly have known of J. M. Dent of Letchworth.

*1905: on one of his frequent visits to Panshanger, Buchan meets Susan, daughter of the Hon. Norman Grosvenor.*

Susan's grandmother was a niece of the Duke of Wellington and her grandfather was Robert Grosvenor, Lord Ebury of Moor Park Rickmansworth in Hertfordshire. In *John Buchan by His Wife and Friends* Susan Tweedsmuir says, 'A great deal of my childhood was spent at it [Moor Park]'. Susan Grosvenor admired strong women such as her friend, the novelist Elizabeth Bowen. Bowen, who spent the latter part of her childhood in Harpenden, Hertfordshire, worked for intelligence in the Second World War. (Did Buchan recruit her?)

*1906: the Everyman series launched by J. M. Dent, and 1s reprints of great literature are published in Letchworth.*

*1909: the Secret Intelligence Service is founded. In order to establish SIS a 'threat to the nation' has to be defined; it is 'The danger to British ports of German espionage'.*

*1910 (2 March): plans for the house in Letchworth where Buchan is said to have stayed with Captain J. Stewart Trotter are submitted.*

Derenda Cottage was 42 Willian Way. Did it back onto a secret RFC rendezvous meeting point? Hitchin historian and ex-BBC newsreader Richard Whitmore says in *Hertfordshire Headlines* that the Royal Flying Corps (RFC — became RAF) had a secret rendezvous point at Willian marked with a huge white cross for landing air scouts on aerial observations. Until it was developed, 42 Willian Way backed on to The Hundred Acre Meadow in Willian. A RFC Deperdussin monoplane crashed on its way to the rendezvous.

On that day in 1912, two years before the outbreak of war, troops were already in training in Letchworth. Buchan would have known this and about the RFC rendezvous point.

The airmen's bodies were taken to the military aerodrome at Willian where the plane was heading. A memorial obelisk to Captain Hamilton and Lieutenant Wyness Stuart, paid for by public subscription, was erected at Willian. *Mr Standfast* contains descriptions of the RFC, the new weapon of war.

*1913: the following is in* The Citizen *small ads: 'A nicely furnished COTTAGE required for short period. 3 bedrooms, bathroom, all conveniences; terms must be moderate. Full particulars to COTTAGE 1846 Citizen Office.'*

In 1913, a Mr Cobbald is listed as living in Derenda Cottage. Was he the owner? Or tenant? If tenant, it would possibly still be known locally as Captain Trotter's cottage.

*1914: war is declared. Twenty spies are arrested and the German spy network is paralysed.*

In *Mr Standfast* Blenkiron told Hannay that '... at the beginning of the war Scotland Yard had a pretty complete register of enemy spies and without making any fuss just tidies them away.' This was precisely what happened. A register of aliens was set up. Special Branch developed a card index system with details on 16,000 potential subversives. Teeming with IRA sympathisers, conscientious objectors and pacifists, Letchworth was under the spotlight. Everyone was under the spotlight. Even Cabinet Minister Richard Haldane and Prince Louis of Battenberg, the King's cousin and First Sea Lord at the Admiralty, were suspected of being German sympathisers. With Gotha planes bombing England, people questioned the loyalty of George V, a Saxe-Gotha-Coburg, hence his name change to Windsor. Even German Shepherd Dogs were renamed Alsatians.

Although he carried the ranks of lieutenant colonel, colonel and major, by his own admission Buchan never served one day in the armed forces. He was told that, because of his poor health, it was useless to think of it. Instead, Charles Masterman, Susan Buchan's cousin, cabinet minister in the Asquith Government and head of the War Propaganda Bureau recruited him.

*1915: Buchan is attached to the army as* The Times *war correspondent (synonymous with intelligence agent) to cover the Western Front.*

In *Mr Buchan, Writer* (1949) Arthur C. Turner says Buchan was based at Chateau Tatinghem near St Omer. He also said that, after the battle of Loos at the end of September, Buchan was called home to work in Intelligence for six months. This is the only time he could have been in Letchworth. Did he stay in Captain James Stuart Trotter's Derenda Cottage some time during October, November or December? Or did he have a *pied-à-terre* in London and commute there? Turner said that during this time Buchan worked a fourteen-hour day.

In *Mr Standfast* Hannay is told that his contribution to the war effort will be much more crucial than anything he could achieve as an army officer. Is this what Buchan was

told? Lord Macmillan wrote in *John Buchan by His Wife and Friends* of Buchan's wartime activities, 'he enjoyed doing work that often bore resemblance to the performances of some of his characters in his novels.' William Buchan (son) in *John Buchan, A Memoir* says, 'Once, when I was lunching with him at the Café Royal, he stopped mid-sentence to say, "Something's just come back to me. I used to interview people here, in an upstairs room, under the name of Captain Stewart."' Andrew Lownie in *John Buchan: The Presbyterian Cavalier* wrote, 'Buchan stayed in touch with his Intelligence contacts and passed on the name of a suitable recruit for the Intelligence Services'.

Buchan knew all about secret codes from his South Africa days. Richard Hannay, surprisingly, broke complex codes in wartime when their use in British Intelligence was known only to agents. Hannay once said he was an 'intelligence-officer... during the Boer War... I used to reckon myself pretty good at finding out ciphers'.

An American, Hollerith, formed the Tabulating Machine Company (TMC). In 1908, TMC gave an exclusive license to the British Tabulating Machine (BTM) in Letchworth. Did Buchan visit BTM, which made code and cipher equipment for the Intelligence Services? By the end of the First World War, Britain's military and cryptographic intelligence services were the best in the world.

In *The Thirty Nine Steps* Hannay says, '... I was getting very warm in my search for the cipher... a numerical cipher... A was J, the tenth letter of the alphabet and so represented by X in the cypher... "Czechenyi" gave me the numerals... I scribbled that scheme on a bit of paper and set down to read Scudder's pages...'.

*1916 (spring): Buchan is back in France as a colonel in the Intelligence Corps sending communiqués to fellow Scot Sir Douglas Haig at General HQ.*

Haig served in the Boer War when Buchan was in South Africa and, like Buchan, was at Ypres.

*1917: Buchan, like Hannay in* Mr Standfast, *has been in khaki for a year. Called home he is appointed by Prime Minister Lloyd George as director of Information.*

*1918: Lord Beaverbrook — owner of* The Daily Express — *is appointed minister for information. Buchan is appointed director of Intelligence. His work involves George V, the cabinet, FCO, the Admiralty, the War Office and a network of secret service agents. Buchan is running an underground spy system very like that of Richard Hannay, Blenkiron and Mary Lamerton in* Mr Standfast.

*1935: Buchan is in Scotland when he receives a telephone call from George V inviting him to an audience in Buckingham Palace. For the first time in history a commoner from humble beginnings is appointed to the high office of Governor General of Canada, receiving all the honours due to a head of state. He represented the king as Baron Tweedsmuir.*

Just what did John Buchan do in the First World War that earned him such a high honour? It's hard to see how Buchan could satirise Letchworth, its zeitgeist and locals in *Mr Standfast* with such accuracy had he not stayed there. Buchan said in *Memory Hold the Door* that he never consciously invented anything for his Richard Hannay books. How did he know Biggleswade and Ickleford or the Wymondleys? That Letchworth was originally Lechford and became known as The Settlement? That the Skittles Inn sold only 'washy cider'? The Letchworth area was 'sown with villages each with its green, pond and ancient church' which perfectly describes Willian, Old Letchworth and Norton then and now?

The population of Letchworth in 1914 was 9,000, of whom 3,000 were Belgian refugees who worked in local engineering firms on munitions (tanks and submarines). Did Buchan visit? Of the many Belgians who wanted Germans out of their country were some working for British Intelligence? For Buchan?

If he was there, it's not surprising no one knew about Buchan's Letchworth visit. When personal papers belonging to Arthur *'Swallows and Amazons'* Ransome came to light, they confirmed what family and friends never knew. Ransome worked for the SIS as Agent S76. The 'S' means he was handled from Stockholm.

During the Boer War Buchan was in South Africa. He must have known colonel, later Major-General Sir James Trotter who, in 1914, set up Special Branch and SIS G (German) Branch to deal with subversion among trade unionists and pacifists. It was Trotter who, in 1914, tried the first German caught spying. Did Buchan work for Sir James Trotter in G Branch?

In Dr Andrew Cook's *M: MI5's First Spymaster* there is — his words — a unique photograph of G Branch taken to commemorate the 1918 Armistice. In the back row is someone who looks very like John Buchan. Dr Cook cites MI5 as the source for the photograph.

Buchan wrote in *Memory Hold the Door* with respect to his wartime activities 'I had... meetings with odd people in odd places... with the queer subterranean world of the Secret Service... This [writing a popular history of the war] was a hard job in France, but it was easier in London — indeed, my difficulty was that I knew too much and was often perplexed as to what I could print.

Alfred Hitchcock, who filmed *The Thirty-Nine Steps*, knew Buchan. Was Buchan the unidentified spy in Hitchcock's film *The Man Who Knew Too Much*? The story involved an international plot to assassinate a high-ranking British diplomat. A hired assassin (Peter Lorre) is to shoot him during a concert at Albert Hall.

In possession of all military and political secrets, no record of Buchan's Intelligence work has ever been published, no account ever made public. Too confidential and too intimately linked with the secret service? So important did Buchan view his services to Britain it's said that he refused two knighthoods as too lowly to reflect it. Just what is it he did which earned him the honour of Governor General of Canada?

The library index cards are a bit of a red herring. Rest Harrow was not Derenda Cottage and Captain Trotter had left Letchworth by 1915 so Buchan could not have stayed with him. If he stayed at Derenda Cottage it was with Mr Cobbald.

The delicious local legend depends on the word of one man, Charles Purdom. Given the man he was, there is no reason not to believe that Mr Buchan was in Letchworth when Purdom said he was. Besides, although minute details of Buchan's whole life has been pored over for the last sixty years, no one has yet managed to prove that he was not there. During a war everything is chaotic. Letchworth has every justification in hanging on to its legend until the day someone somewhere says 'wait a minute, that can't be right'.

Nothing was known about Captain J. S. Trotter until very recently. Peter Harkness, a member of the famous horticultural family, who lives in Letchworth, has done some very impressive detective work worthy of Richard Hannay himself. He unearthed the following fascinating facts:

> 1911 Census Resident 13 Embankment Gardens, Chelsea SW. James Stuart Trotter, head, age seventy-two, married less than one year, born Edinburgh. Ada Derinda Trotter, wife, age thirty-seven, married less than one year, three children, none of them resident, born Regents Park.
>
> Trotter married Ada Derinda 12 December 1910 at Chelsea Register Office. James Stuart Trotter, seventy-one years, widower, of independent means, resident at 13 Embankment Gardens, Chelsea. Groom's father: Archibald Trotter (deceased) was a Captain in the Scots Greys. Bride: Ada Constance Hole, thirty-eight years, widow, resident at Willian Cottage, Letchworth. Bride's father: William Pinkney, farmer. Witnesses: Cissie Lowman & W H Lowman. Ada Constance D. Pinkney was born in Pancras Registration District 1873. Ada Pinkney married Mr Hole in 1892.
>
> Captain J. S. Trotter died in Kensington aged 83 in 1922.

The Index Cards in Letchworth Library which started off the paper trail now have a handwritten note, 'This information came by word of mouth and has not been verified in any documentation in the library.'

---

The John Buchan Society can now amend its review of *Mr Standfast* because one fact, at least, has been established. Biggleswick is definitely Letchworth Garden City. In August 2009, his granddaughter Lady Stewartby wrote to the author, '… My father, William Tweedsmuir, who died last year, told my husband when he was adopted as the Conservative candidate for North Hertfordshire in 1972 that John Buchan would have been amused and delighted that a new link was to be established with the place he, John Buchan, had written about in *Mr Standfast*.'

Lady Stewartby married Sir Ian Stewart who took his seat in the Upper House as Lord Stewartby in 1992. They live on the Scottish borders in Broughton Green, the home of John Buchan's mother's family, the Mastertons. Broughton Green is said to feature in several of his books including *The Thirty-Nine Steps*.

The British Pathé News website has many clips of John Buchan.

# CHAPTER 18

# THE CHURCHILL FAMILY

## IN ICKLEFORD

The world-famous Churchill family has many connections with Hertfordshire. John Churchill, 1st Duke of Marlborough, married Sarah Jennings of Sandridge, St Albans. (Incidentally, he spent £340,000 p.a. on his espionage service, the best in Europe.) Clementine Hozier Churchill was brought up in Berkhamsted, and Winston was a close friend of the Lyttons of Knebworth House. Clementine and Winston announced their engagement at Salisbury Hall, London Colney, where his mother, Jennie Jerome Churchill, lived.

During the war, Winston's son, Randolph, and his wife, Pamela Digby Churchill, lived in the rectory (demolished) in Ickleford. Randolph was a major on the General Staff Intelligence Branch.

In 1944, when his father said that Yugoslavia must be helped, SOE parachuted Randolph — code-name Apple — in. His close friend, Evelyn Waugh, joined him in the Fitzroy MacLean mission to General Tito. Although the partisans appreciated that Churchill had sent them his only son, they were not impressed by Randolph's heavy drinking or lack of commitment to their cause.

Randolph and Pamela moved to Ickleford just before the birth of their only child, Winston Junior who, contrary to local legend, was not born or christened in the village but at Chequers, the Churchill's official country residence. He did, however, spend the first year of his life in Ickleford and residents remember his nanny pushing the red haired baby around the village in his pram.

Clementine Churchill, then fifty-four, was the first to admit that, as the wife of one of England's greatest men, she was a success but as a mother of five children, less so. Her uncharacteristic visits to Ickleford were her attempts to build bridges between herself and her wayward son.

Winston wanted a Churchill dynasty, so, in 1940, Randolph, an officer with the Queen's Own Hussars, thinking he might be killed in action, proposed to eight women in quick succession. All turned him down. Mutual friends of Randolph, twenty-eight, and of

Pamela Digby, nineteen, the pretty red-haired daughter of Lord and Lady Digby of Cerne Abbas, Dorset, arranged a blind date. Ten days later they were engaged.

Clementine warned Pamela of Randolph's drinking, rudeness, aggression, womanising and gambling. She, with Pamela's parents and Randolph's friends, advised her to call the engagement off, which she did. But Randolph persisted and a week later they were married. The wedding photos (see British Pathé News) show guests carrying gas masks.

When Pamela became pregnant, she moved into 10 Downing Street with her in-laws until the day Randolph came home on leave, got drunk and left classified military maps in her car which were returned by the police. When a furious Clementine told him to leave the house, the couple moved to Ickleford.

The rectory, which belonged to St Katherine's church, was a huge, eleven bedroom, ramshackle place, so cold no rector had lived there since 1888. Pamela said, 'The house was very cold... I used to go to bed at 6.30pm so as to turn off the gas fire.' Mrs Beecher, who lived locally, was taken on as housekeeper.

When Winston Junior was born in October 1940, Randolph couldn't be found. Recently voted in M.P. for Preston, Lancashire, he was on a three-day drinking binge but in November when, sitting next to his father, he made his maiden speech in the House of Commons, Pamela and Clementine were in the Gallery to support him. Six months later, May 1941, the House of Commons was blown to smithereens by a German bomb.

In Ickleford, to help the war effort, Pamela helped run a British Restaurant in the village hall to provide cheap, nourishing meals for 300 people who came every lunchtime, mostly factory workers from the Hitchin area. She also attended local functions where her presence as daughter-in-law of the prime minister gave much pleasure.

In February 1941 when Randolph was sent overseas, Pamela was again pregnant so she asked his sister Diana, wife of Duncan Sandys, and her children to join her and Winston Junior at Ickleford. Three weeks later she received a bombshell telegram. Randolph who had lost a fortune gambling, instructed her to send him money and not tell his parents. She sold her jewellery and wedding presents but the anxiety brought on a miscarriage and shattered the marriage. Frantic with worry, Pamela went to see Randolph's old employer, newspaper magnate Max Beaverbrook, who invited her to leave Winston Junior and his nanny at his country house while she found a job.

After the war, Pamela began divorce proceedings. When Randolph lost his Preston seat he returned to Ickleford. He invited Winston Junior, now nearly five, to join him and his friend Evelyn Waugh and his six-year-old son Auberon to celebrate VJ-Day 14 August 1945. Waugh assured his wife that 'Winston's nurse is able and willing to look after Bron'. He wrote to her from the rectory.

Dear Laura... went to luncheon with a neighbour, Audrey James-Coates in a pretty Queen Anne house with her lover and two pretty sons. Cook has come — a frail gnome of eighty or ninety — brought here under false pretence in the belief there were other

*Ickleford Village Hall*

servants... the house is comfortless and the telephone rings far too often... few of the doors have fastenings and the wind whistles through the house. I am very cold. Please send me my grey tweed herringbone suit.

This visit to Randolph in Ickleford is Winston's first memory of his father who, as a Blitz baby, he didn't know. The village was floodlit, there was a firework display and the boys baked potatoes in a bonfire. Winston remembers the visit as 'magical'. He also remembers the walled garden bounded on one side by the church and playing 'bears' with his father chasing him up into the branches of a large tree 'ideal for climbing'. He remembers his father reading him the leader article in *The Times* every day and said living with him was like walking hand in hand with a volcano.

When Randolph gave up the house and Pamela moved abroad, Winston divided his school holidays between grandparents.

Light years away from Ickleford Village Hall canteen, Pamela's war effort in the Dorchester Hotel, London, where the menu included lobster, oysters, partridge and champagne, was of an entirely different kind. As Winston's confidante, she became a courtesan picking up pillow talk from diplomats and generals. Nigel Dempster, the gossip columnist, said she

knew more about rich men's ceilings than anyone. Because the Dorchester was built with reinforced concrete, it was dubbed the best air raid shelter in London. Pamela spent air raids under the beds of the military such as Lord Portal, Chief of Air Staff and General Fred Anderson, American Air Force Bomber Command boss in Britain. Afterwards she told Churchill what they said about him.

Randolph died in 1968.

As Pamela Harriman, the ex-Mrs Churchill was President Bill Clinton's mentor and his US Ambassador to France. When she died in 1997, she left Winston £6 million to be shared with his estranged wife, the mother of her grandchildren — disapproving of his decision to leave his wife of thirty-one years who had endured his string of mistresses. He also came under attack for asking John Major for £12 million for his grandfather's papers. Shocked historians assumed the country already owned them.

The rectory in Ickleford was bought by Martin Dent of the Letchworth publishing firm J. M. Dent. Demolished in the 1960s, the site is now housing.

# CHAPTER 19

# THE WAUGH BROTHERS

## EVELYN AND ALEC

Evelyn Waugh is remembered for *Brideshead Revisited*. Such is the power of television. His brother, Alec, is remembered for *Island in the Sun*. Such is the power of film.

Both brothers were Intelligence agents. Alec worked for MI6 in the Middle East and Evelyn was in Yugoslavia with Winston Churchill's son, Randolph. In true brotherly tradition, Evelyn's nickname for Alec was 'the bald-headed lecher'. When Evelyn's son, Auberon, was expelled from Oxford he told him that he would have to 'become either a schoolmaster or a spy'. The brothers were friendly with fellow spies Graham Greene, John Betjeman, Elizabeth Bowen and Ian Fleming. Their cousin, Claude Cockburn, who was in Berkhamsted Collegiate School with Greene, was suspected of being a Communist spy but never was.

In the run up to the First World War, Alec Waugh of Inns of Court Officer Training Corps was stationed in a house named 'Avil' in Cowper Road just off the High Street in Berkhamsted. He married Barbara Jacobs, daughter of W. W. Jacobs, William Jacobs, author of horror stories including the macabre *The Monkey's Paw*. The Jacobs, who lived at 'Beechcroft' (demolished) in nearby Chesham Road, gave parties for soldiers billeted in the town.

William Jacobs was a friend of Alec's publisher father, Arthur Waugh, who might even have published Jacobs' work. He knew everyone in Berkhamsted including the Greenes, Cockburns and the Quenells. Peter Quennell, a friend of the Jacobs brothers, was often at the house when Evelyn Waugh was there, as was Gilbert Cannan of The Mill in nearby Cholesebury who eloped with J. M. Barrie's wife. In the Jacobs' huge house there was, as well as five noisy children, a non-stop continuing quarrel. Mrs Jacobs was a militant suffragette who ended up in Holloway. Evelyn Waugh loved the story of her kidnapping her children from the school her husband put them in to put them in another of her own choosing.

Alec and Barbara got married in St Peter's church, Berkhamsted. His cousin, Louise Cockburn, Claud's sister, was bridesmaid (her daughter married Omar Pound, son of

Ezra). The wedding reception was held at Beechcroft, Barbara's home. Although the marriage did not last, Evelyn says in his autobiography, *A Little Learning*, that he continued to visit the Jacobs.

In 1917, Alec published *Loom of Youth* about homosexuality in public schools. He also wrote a story about Berkhamsted called *Pleasure* and of the Jacob family and their parties in *My Brother Evelyn and Other Portraits*.

The Waugh family was close to Roger Hollis, head of MI5, rumoured to have been a double agent. His brother, Christopher Hollis, was Alec's godfather. Another relative, Auberon Herbert, worked in Intelligence in the Middle East, as did Alec Waugh.

Alec wrote about his work in Counter Intelligence during the Second World War. His story, *A Spy in the Family*, is about Victor, a Treasury official living a boring life until his wife, Myra, discovers his odd routine. His novel, *Mule*, is the story of Noel Reid, a professor of history and philosophy posted in 1941 to the Intelligence unit in the Lebanon. He joins forces with Nigel Farrar, boss of MI5 in Beirut, to recruit Lebanese for service in the Allied cause to relay misleading information to the Germans in Istanbul. When Noel revisits the Lebanon many years later and meets up with Farrar, they agree they had thoroughly enjoyed the war. Alec Waugh's *Island in the Sun* was made into a successful film staring James Mason.

# CHAPTER 20

# GEOFFREY DE HAVILLAND

## — AND HIS MOSQUITO

... it makes me furious when I see the Mosquito. I turn green and yellow with envy. The British, who can afford aluminium better than we can, knock together a beautiful wooden aircraft that every piano factory over there is building, and they give it a speed which they have now increased... There is nothing the British do not have. They have the geniuses and we have the nincompoops...

Hermann Göring, January 1943

Geoffrey de Havilland's Mosquito was designed and manufactured in secret in Hertfordshire. Made from ply, spruce and balsa wood, it was dubbed 'The Wooden Wonder', 'Mossie' and 'The Balsa Bomber'. To accelerate glue drying, de Havilland developed a technique of heating it using radio waves. The pilot and navigator sat side by side. One of the fastest aircraft around it was also the most manoeuvrable. It climbed faster and turned more quickly than a Spitfire.

De Havilland thought of the idea of a wooden aircraft to take advantage of the underused resources and skills of the furniture industry during wartime. The Air Ministry was not interested until it saw the performance of the prototype. The design dated from 1938 but it was not until 1940 that there was sufficient interest for construction to begin when de Havilland Junior took the prototype Mosquito into the air for the first time. Its performance was a revelation.

The Mosquito prototype, designed and made in secret at Salisbury Hall London Colney, is, miraculously, still there.

Salisbury Hall was once home to Winston Churchill. When his mother, Jennie Jerome Churchill, married her second husband they moved into the Hall. This is where Winston announced his engagement to Clementine Hozier from Berkhamsted and this is where he returned to inspect the Wooden Wonder.

Before the war, de Havilland's chief designer R. E. Bishop, conceived the idea of a light bomber which could exceed the speed of contemporary fighter planes. Powered by

*The Mosquito: De Havilland Aircraft Heritage Centre, London, Colney*

two Rolls-Royce Merlin engines, it would be faster than any fighter able to reach Berlin. As current aircraft programmes needed all available metal it was built from wood. The Wooden Wonder could carry the same bomb load of a four-engine B-17 Flying Fortress and capable of making two round trips in a night.

In order to design the Mosquito in secret, the team needed somewhere near de Havilland's works at Hatfield. Salisbury Hall, requisitioned for the war effort for de Havilland, was ideal. The first of 7781 made, the Mosquito was ready by 1941. The prototype W4050 was built in a hangar disguised as a barn behind the hall. Winston Churchill came to see it with Air Ministry officials and in service bomber crews.

When the Air Ministry ate humble pie and agreed to order a supply, the W4050 was dismantled like IKEA flat-pack furniture and taken on a lorry from Salisbury Hall to the de Havilland factory in Hatfield; this is the factory which the Germans sent Eddie Chapman to blow up.

The de Havilland Company left Salisbury Hall in 1947. In 1955, when ex-Royal Marine Major Walter Goldsmith restored it and opened it up to the public, he brought back the prototype Mosquito, W4050. This led to today's wonderful de Havilland Aircraft Heritage Centre and Mosquito Aircraft Museum. It was not until 1961 that the last Mosquito was withdrawn from RAF photo-reconnaissance units.

When Clementine Hozier met Winston Churchill, they discovered a shared sense of black humour and made each other laugh. They had a lot in common. Clementine's mother and Winston's mother were both notorious, beyond the pale of polite society.

A few days after their meeting, Clementine received an invitation to visit Winston's mother, Jennie, at Salisbury Hall, from where a delighted Jennie would later announce their engagement. After the honeymoon, the couple lived there until they found their own place.

Jennie Jerome, a beautiful American 'dollar princess', united her vast fortune to an English title. Dressed by Worth, wearing diamonds by Cartier, she married Lord Randolph, son of the Duke of Marlborough, at Blenheim Palace where her son, Winston, was born seven months later.

When Randolph died of syphilis at forty-six, Jennie scandalised society by marrying handsome, penniless George Cornwallis-West, twenty-five, the same age as Winston. She was forty-five. They rented Salisbury Hall, a lovely Elizabethan moated mansion with grand staircase and oak-panelled rooms and gave great parties at which guests punted on the moat. Frequent guests included the equally notorious Alice Keppel (mistress of Edward VII) and the actress Maxine Elliott of Hartsbourne Manor, Bushey Heath. Keppel shocked Clementine by advising her to become the mistress of someone with money.

Maxine's parties were even more talked about than Jennie's. Guests arrived by new-fangled contraptions called airplanes. The whole of Bushey Heath turned out to see them land. At Hartsbourne, Maxine had installed central heating and bathrooms (unheard of in England) and built a suite on to her private rooms for 'Kingy' (Edward VII).

After her divorce, at sixty-four, Jennie again scandalised society when she married Montagu Porch, an Australian sheep farmer, who, at forty-one, was younger than Winston.

Winston never got over his adored mother's tragic death. In 1921, Jennie, sixty-seven, wearing high heels, tripped and fell downstairs breaking her ankle. Gangrene set in so her leg was amputated. She died following a haemorrhage. She was buried in the Churchill family plot at St Martin's Church, Bladon, Oxfordshire, next to Winston's father, Randolph.

# CHAPTER 21

# GENERAL DE GAULLE

## AN ANGLOPHOBE IN ASHRIDGE

'... head like a pineapple - hips like a woman'
Alexander Cadogan FCO Diary 1940

During the Second World War, the then unknown General Charles de Gaulle lived near Berkhamsted from 1942 until he moved his Resistance HQ from London to Algiers to fight the war from there. He rented the newly built 'Rodinghead' in Ashridge from its owner, Colonel Johns. He moved in with his wife Yvonne and their thirteen-year-old Downs Syndrome daughter Anne and her nurse. When Anne died in France in 1948 age twenty, her grieving father, who adored her, comforted his wife saying 'she is now like everyone else'. Their son Philippe, twenty-two, a cadet in Portsmouth naval school and their other daughter Elizabeth, a university student, visited often. Philippe rose to admiral in the French Fleet.

'Rodinghead', the house de Gaulle rented, is on the road to Ashridge House. Yvonne de Gaulle described it to her niece as an 'attractive, modern, pleasant villa'. With its large security-controlled gates, it's as private and as inaccessible today as it was in her day — the perfect hideaway for a man with a price on his head.

When de Gaulle moved in, he had the cellar strengthened to use as an air raid shelter. Churchill ordered cine films and photographs be taken of the couple to promote de Gaulle and his Free French. Photos in magazine and newspaper articles at Hertfordshire County Archives show the General and Madame de Gaulle playing the grand piano, standing at the AGA tasting soup and taking the sun on the terrace.

The Institute Charles de Gaulle in Paris minted a commemorative medal engraved Rodinghead Ashridge. Madame de Gaulle was described as de Gaulle's sad-eyed wife. She had plenty to be sad about. The family attended Mass every Sunday at the Roman Catholic Church of The Sacred Heart in Park View Road Berkhamsted. When de Gaulle made an official visit to nearby Potten End to take the salute from the Home Guard on Remembrance

*Rodinghead*

Sunday, he was furious a French flag could not be found anywhere. Complex, difficult and scratchy, de Gaulle was a devoted family man who wrote tender love letters to his wife when they were apart. At home in Berkhamsted he was never in uniform.

In December 1941, de Gaulle invited Colonel Passy, his head of Intelligence, to spend the weekend at Rodinghead. Passy's real name was André de Wavrin. Passy, his code-name, was the Metro station near his home in Paris. Like de Gaulle, he was jealous of Britain. To prevent Churchill from finding out what he was up to he used a separate, secret code. Nevertheless, Britain awarded him the DSO and MC for his war work. Unlike de Gaulle he managed to disguise his antagonism toward Churchill's Special Operations Executive (SOE). He had to. Having managed to muster only 400 resistance volunteers he couldn't achieve much without it. For its part, SOE did not see bringing de Gaulle to power as one of its aims. In France, many French Resistance leaders had no time for Passy and refused to have anything to do with him. De Wavrin, one of the few confidants of de Gaulle, shared many of his personality traits and made as many enemies. He never forgave those who criticised him or let him down. After the war, de Wavrin was head of intelligence until de Gaulle resigned in January 1946. Like de Gaulle, he involved himself in many controversies including a quarrel with eminent historian Professor M. R. D. Foot over his official history of the SOE.

After a long walk in the surrounding countryside in Ashridge commenting on the depressingly slow resistance of French people to the Nazis, Passy asked to be removed from Intelligence and allowed back to his fighting unit. De Gaulle refused saying he was far more use to the cause where he was. 'We came back from our long walk,' said Passy in his memoirs, 'and sat down in armchairs in the drawing room. The General switched on the radio. The Japanese had just attacked Pearl Harbour. The General said "Now the war is certainly won... the future has two phases... the first ...the salvage of Germany by the Allies... the second... war between the Russians and Americans".'

Although de Gaulle sneered at the SOE, it helped his rise to power. When he and his 2nd Armoured Division were reluctantly allowed to join the USA Army when it entered Paris on 25 August 1944, he strode the streets like a conquering hero as if he, personally, had liberated France. He then ordered all SOE personnel to leave France. On 13 November, he was elected head of the French government.

De Gaulle repeatedly blocked Britain's attempts to join the European Economic Community (EEC). He said it lacked commitment to Europe (*plus ça change*). Following student riots against him, de Gaulle resigned in 1969 and died shortly after in 1970.

Born in Lille, his father, headmaster of a Jesuit school, was a staunch supporter of Alfred Dreyfus during his exile on Devil's Island.

De Gaulle joined an infantry regiment commanded by Colonel Henri-Philippe Pétain. In the First World War, he fought at Verdun where he was wounded three times. Captured by the Germans and held in prisoner of war camps, he made five attempts to escape, but at six feet five inches he was not difficult to hunt down.

In May 1940, de Gaulle was the only French commanding officer who forced the Germans to retreat. He was appointed minister of war but, when Pétain collaborated with Hitler and formed his Vichy government, an appalled de Gaulle said it was treason and declared himself leader of the Free French. He wanted to call them Fighting French because he said they were not free but were fighting.

Pétain at de Gaulle's court martial sentenced him to death. In fear for his life, he was given refuge in London where he made a BBC radio broadcast calling on the French to continue fighting.

18 June 1940. I, General de Gaulle, now in London, call on all French officers and men who are at present on British soil, or may be in the future, with or without their arms; I call on all engineers and skilled workmen from the armaments factories who are at present on British soil, or may be in the future, to get in touch with me. Whatever happens, the flame of the French resistance must not and shall not die.

His right-hand man at the BBC was Emile Delavenay who helped him in his propaganda war against Germany. During the war, Delavenay's daughter was a pupil of Hitchin Grammar School. She is now better known as the successful writer Claire Tomalin.

President Roosevelt considered France a defeated nation. Dismissing de Gaulle as in no way representative of the French, he recognized Pétain's government. Churchill did not. He backed de Gaulle as leader of the 'Free French'.

Completely unknown to the French at the beginning of the war, in 1941, three million tuned in to his broadcast when de Gaulle urged them not to kill Germans because Nazis had massacred the French at Lille and Nantes using resistance as an excuse.

De Gaulle, described as a proud beggar, received money, uniforms and equipment from Churchill who devoted time, resources and finances he could ill afford as London was reeling from the Blitz. Although he wanted nothing to do with Churchill's SOE, the SOE in France took up more of SOE time, money and effort than any other occupied country except for Yugoslavia. In fact, de Gaulle's Free French resistance depended on SOE, the first link in the chain of resistance for training and aircraft. F (France) Section employed 480 agents. Over 1,000 drops were made to agents and resistance groups in France. D-Day 1944 defined SOE's mission in France. On Thursday 1 June, six days before the D-Day invasion, hundreds of coded messages were broadcast by the BBC to Resistance groups and SOE agents.

No good turn ever goes unpunished. Churchill said France's hatred of Britain was stirred up by de Gaulle. In a French TV poll, de Gaulle was voted the greatest Frenchman ever.

# CHAPTER 22

# ALAN TURING

## THE ENIGMA BOMBE

Germany's Enigma machine was manufactured in Poland in the 1920s for the German banking industry. In 1931, when the Germans gave the instruction manual to the French, the French gave copies to the Poles and the British. Sensing the growing threat from Germany in Jul 1939, the Poles gave France and Britain a machine each. By then the German Navy had adapted the system of rotors, keyboard and electric wires for its own use.

Resembling a typewriter, the portable machine, ideal for use in combat, was adopted by all branches of the German armed forces. The Germans changed the cipher every day and equipped Enigma with extra wheels and separate codebooks to create ever more complex encryptions. Enigma protected German radio communications, allowing their U-boats to inflict massive losses on British shipping and the Luftwaffe to strike suddenly with devastating effect.

Throughout the war, British mathematicians and cryptanalysts based at Bletchley Park near Milton Keynes worked round the clock to unscramble streams of intercepted Enigma messages. The capture of codebooks from a German U-boat on 9 May 1941 led to a breakthrough.

The Enigma, which can be seen at Bletchley Park, is a code-making machine. Mathematical genius Alan Turing, based at Bletchley, invented an electro-mechanical code-breaking machine known as a Bombe. It succeeded in finding Enigma wheel settings not by proving a particular setting but by disproving incorrect ones.

Although Germany's coded messages were successfully intercepted at Bletchley (Station X), they were completely unintelligible. Francis Bacon's codes based on letter frequency and linguistic patterns could not crack Enigma. A new form of encryption based on mathematics was enciphered on machine wheels in ever-changing alphabetic substitutions. Wheel orders and settings were changed at midnight every day.

Text was typed using a keyboard. When an electric current was passed through the Enigma machine the text was scrambled and a lamp board lit up with the cipher (text in code form). Each letter of the alphabet could be given a different code every time it was

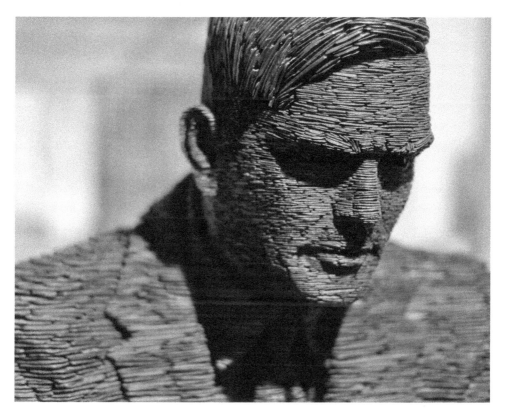

*Alan Turing sculpture by Stephen Kettle: Bletchley Park Museum*

typed. Inside the machine are wheels known as rotors. The operator had a choice of five. The machine had ring settings which moved one place every time a letter was used. It also had a plug board which allowed letters to be joined together in pathways, e.g. if the letter A was typed, the electric current would follow the path to another letter. There are 150 million million million possible combinations inside the Enigma machine. Every day German operators were given a new key sheet telling them how to set up their machines for that day. By 1945 Enigma variants were known but not all were broken.

Each one of Alan Turing's Bombes weighed, quite literally, a ton. The Bombes, 210 of them, were made by the British Tabulating Machine Company (BTM) in Letchworth Garden City. Turing, the great man himself, visited several times to monitor progress. Why so many? Because the volume of encoded messages increased enormously after 1941.

When Turing sketched his design for the Bombe, Commander Travis of Bletchley Park took it to BTM chief engineer Harold 'Doc' Keen, holder of over sixty patents. Doc — he carried a medical style bag — joined BTM at eighteen in 1912. He was given an OBE after the war. His assistant, H. J. Morton, was given an MBE. No one was told why. BTM chairman Raleigh Phillpotts, who was given a knighthood, issued a certificate to thank key people: 'It will be gratifying to you to know that HM Lords Commissioners of the

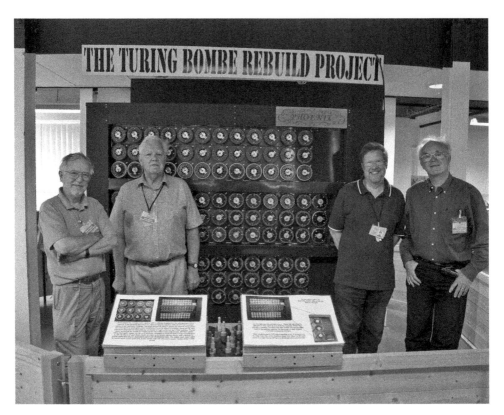

*John Harper (second left) with three of his team, Bletchley Park Museum*

Admiralty have expressed their appreciation of the rapid and efficient production of the Cantab equipment which has materially assisted in the successful prosecution of the war.'

The Bombes were destroyed after the war but John Harper, an engineer who lives in Ickleford near Letchworth, spent twelve years supervising sixty volunteers on a project to rebuild one for Bletchley Park Museum. Its actual cost might have been as much as a million pounds had not companies worked for nothing. He started in his living room with the component drawings. The assembly drawings, which had been destroyed, took two years to recreate. The replica Bombe, which includes thousands of components, was, like its predecessor, made in various locations. The final parts were assembled at Bletchley Park in 2008 where it is on permanent display. The Rebuild team met some of the WRNS who operated Bombes in the war.

No one knows where the name Bombe came from. It's thought it might have been dreamed up by the Poles because the machine resembled their slab-like 'bomba' ice cream. Each black iron monster, looking nothing like a bomb but very like a cupboard, was six feet high, eight feet wide and three feet deep. Inside was a labyrinth of cables and gears. On the face were rows of wheels one and half inches thick, five inches in diameter with the twenty-six letters of the alphabet inscribed round the circumference.

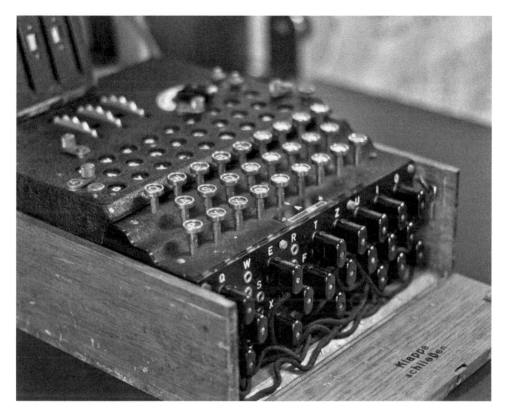

*Enigma machine, Bletchley Park Museum*

Security at Letchworth was as good as it was at Bletchley Park and although hundreds of personnel were involved, the secret of the Bombe was kept for forty years. Security was deliberately low key. A single soldier with an army lorry collected Bombes from the loading ramp clearly visible from the main road. He then set off for Bletchley with no escort so nobody took any notice. The first Bombe, which took nine months to make (later ones took just one week), was christened Agnes. It was delivered to Bletchley in March 1940. Subsequent Bombes were named after British planes, towns and cities. Later this was extended to include major cities in countries that were part of the Allied cause.

Sub-assemblies were produced at various Letchworth addresses. Women did the wiring at the Spirella factory which made wire corsets, the frames were made in the engineering department in the basement of the Ascot Government Training Centre, Pixmore Avenue (George Orwell enrolled in 1939 as Eric Blair) and the parts assembled at the company's factory in Icknield Way. Employees, who worked round the clock in shifts, had no idea what they were making. The Bombe was Cantab Order Number 6/6502.

Bletchley Park sent a menu with each job which members of the Women's Royal Naval Service (WRNS) at the outstations where the Bombes were located followed. They put the drums in the correct order according to the menu starting positions, plugged in the

cables and turned on the machines, six, seven or eight at a time. The noise was dreadful. No natural light, very little fresh air, no modern health and safety ear muffs, no two hours on, two hours off rules. Shifts were eight hours. No wonder 'Wrens' called Hut 11 the Hell Hole. ULTRA, the highly secret information retrieved from code-breaking, gave warnings of Hitler's preparations for the invasion of Britain. Its success was due to the fact that Germans assumed Enigma codes were unbreakable. It's said that ULTRA was made available to only twenty people; one was KGB Agent Kim Philby.

The cavalier way we care about our heritage is shameful. The famous BTM site in Icknield way is now Tabb's Close, yet another housing estate.

# CHAPTER 23

# DICK WHITE

## BISHOP'S STORTFORD COLLEGE — A VERY NON-CONFORMIST PLACE OF LEARNING

Bishop's Stortford College — founded in 1868 — inculcates self reliance. It also inculcated seven high-ranking members of the Intelligence service including two heads of MI5 including Sir Dick White, Britain's most respected and experienced Intelligence chief, the subject of Tom Bower's *The Perfect English Spy*.

The photograph shows the Memorial Hall. Designed in Georgian style by famous architect Sir Clough Williams-Ellis, it was built in 1922 to commemorate sixty-two Old Boys who died in the First World War. It now also commemorates the 154 former students who died in the Second World War.

MI5 was founded in 1909 as the Secret Service Bureau. Of its fifteen director generals, three went to Bishop's Stortford College. One is Sir Stephen Lander of the Joint Intelligence Committee (JIC). Other Old Stortfordians include Peter Wright who became assistant director general of MI5. When he published *Spycatcher*, Prime Minister Margaret Thatcher tried to suppress it. In it Wright claims that Hollis, head of MI5, was a Soviet double agent, the fifth man in the spy ring that included Kim Philby, Guy Burgess, Donald Maclean and Anthony Blunt.

In 1945, when Igor Gouzenko defected and said there was a Soviet spy ring in Britain, the case was passed to Philby who suggested Gouzenko be interviewed by Roger Hollis. Gouzenko told him there was definitely a Soviet agent inside MI5. Hollis showed no interest. When MI5 Agent Nicholas Elliott interviewed Philby in Beirut, he said he got the impression he had been tipped off to expect his visit from someone inside MI5.

In the early days, recruits to the secret service were through personal recommendation. Considered an honour to join an elite club, they had to supplement a paltry income so spying was for many a part-time employment. When he was approached in 1936 to work for MI5, Dick White said no. The pay offered was £350 p.a., less than the £700 p.a. he was getting as teacher. The offer was upped.

*Bishop's Stortford College*

White, who served nine prime ministers, played a major role in military and political affairs from the rise and fall of Hitler to the Cold War. He was private secretary to Guy Liddell. Fluent in German, in 1936, Liddell sent him to Germany to observe Hitler at close quarters. During the war, Dick White introduced the Double Cross system — German spies persuaded to double-cross their masters. Until then, picked up the moment they arrived in Britain, many were executed.

When Bletchley Park confirmed that Eddie Chapman, code-name Fritz, was on his way over, Operation Nightcap was put into action. White was called on his secret telephone, Fighter Command was alerted to track incoming planes and the chief constable in the area contacted. They were not needed. On landing, Chapman contacted the police and offered to work for MI5.

White wasn't always successful. In 1939, he interviewed Walter Krivitsky, a senior Soviet Intelligence officer who had defected. Krivitsky gave details of British KGB agents. He did not know the names but said one was a journalist who worked for a British newspaper during the Spanish Civil War. This was Kim Philby. Another was 'a Scotsman of good family, educated at Eton and Oxford'. This was Donald Maclean. Dick White did not believe him. Krivitsky was murdered in the Bellevue Hotel, Washington, in 1941.

In 1950, when Philby was suggested as the next director general of the MI6, White was asked to produce a report on him. He found that the description of the 'mole' provided by Krivitsky and Gouzenko matched Philby's time in Spain as a journalist. He came to the conclusion that Philby could be a double agent.

Dick White became director general in 1953. In 1956, MI6 hired frogman Commander 'Buster' Crabbe to examine the hull of a Soviet ship in Portsmouth to check its anti-submarine and mine detection capabilities. On board were Soviet leaders Bulganin and Khrushchev. Crabbe was never seen again. A headless body washed ashore is believed to be him. After the débâcle, Dick White was moved from MI5 to chief of MI6 where he remained until he retired in 1972, the only person to have headed both organisations.

After two years' investigation, Dick White identified Donald Maclean as a Soviet spy. He then turned his attention to Kim Philby. In 1962, Philby knew his number was up. MI6 Agent George Blake had recently walked into a trap and was imprisoned in Wormwood Scrubs for forty-two years, one for every agent he exposed. He escaped after five. Admiralty spy John Vassall was rumbled and the Profumo scandal was about to erupt. Philby moved to Moscow in January 1963.

At Bishop's Stortford, White may have been taught by Brendan Bracken who lied to get his teaching job there. Elected to the House of Commons in 1929, Churchill appointed Bracken his parliamentary private secretary on the outbreak of war. Bracken, bizarrely, insisted he was Churchill's illegitimate son, which Churchill denied. He became Minister of Information, First Lord of the Admiralty and a viscount in 1952 — not bad for the son of an IRA Fenian, and an unattractive one at that. He had wiry, unruly, unkempt red hair, decayed teeth and wore spectacles with very thick lenses. An inveterate liar, Randolph Churchill described him as 'the fantasist whose fantasies had come true'.

Dick White may also have been taught by Eric Whelpton, another wartime intelligence officer, a James Bond-type character in MI5. Bishop's Stortford College says, 'He and Bracken were close friends; Whelpton moved in high society; Dorothy L. Sayers based Lord Peter Wimsey on him; Whelpton lodged in Bishop's Stortford at the Old Boars Head opposite the church; he was Bracken's entré into the upper echelons.' As a son of a known Fenian he would never have attained the positions he did such as Viscount Bracken had he not completely reinvented himself. Bracken had successfully transmuted from someone with a dodgy Irish Republican background into a British public school boy (he had also blagged his way into a minor public school).

White was friendly with spies, Evelyn Waugh, Graham Greene and Malcolm Muggeridge. His contemporaries at Bishop's Stortford included Edward Crankshaw, attached to the British military mission to Moscow during the war, advisor to the government on Soviet affairs; and Dennis Greenhill who became the head of the Foreign Office. In 1971 it was Greenhill who told the Russians that ninety Soviet diplomats were to be expelled for spying. In 1952, his colleague in Washington was Guy Burgess, the Soviet spy.

# CHAPTER 24

# EDDIE CHAPMAN

## AGENT ZIGZAG

'Fiction has not, and probably never will, produce an espionage story to rival in fascination and improbability the true story of Edward Chapman, whom only war could invest with virtue, and that only for its duration'.

Colonel 'Tin Eye' Stephens, head of MI5 Interrogation

When you stand in front of what is now Manor Lodge School in Shenley it is impossible not to marvel at the way Eddie Wearside, aka Chapman, born into poverty in Newcastle in 1914, ended his life owning this impressive mansion. It was certainly not via the nine-to-five wage slave route.

In 1938, lunching with his girlfriend Betty Farmer in a Jersey hotel, Eddie Chapman, twenty-four, a wanted man on the run, spotted two policemen from Scotland Yard enter the dining room. He jumped out the window and ran. After the war, he traced Betty down and married her.

In 1944, Chapman was Baron Stephan von Gröning's guest of honour at a lunch in the German SS HQ in Paris. In 1979, Von Gröning was guest of honour at the wedding in Shenley of Chapman's daughter Suzanne (Mrs Shayne?). Betty Chapman said they were as close as brothers and sang Lili Marlene together.

When Eddie Chapman, born Eddie Wearside in Newcastle in 1914, grew up he would be famous in Britain as Agent Zigzag and in Germany as Agent Fritz, one of the most amazing double agents of the Second World War.

Chapman, or was it Wearside, was a member of the 'jelly gang' which specialised in robbing safes by blowing them open with gelignite. His skill allowed him to live the life of a wealthy playboy in Soho, mixing with the likes of Noel Coward, Ivor Novello and Marlene Dietrich.

In the 1930s, after burgling a string of Odeon cinemas, Chapman went on the run. He ended up in Jersey where he was eventually traced and jailed. When the Nazis

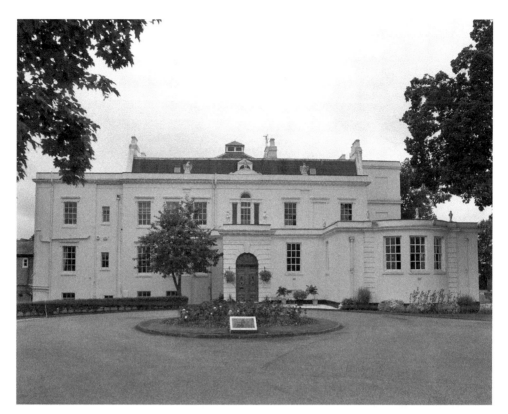

*Shenley Lodge*

occupied the Channel Islands, Chapman, to get out of prison, volunteered for the German secret service.

In 1942, Bletchley Park managed to decode a message from Chapman but was totally mystified by it: 'From Abwehr Nantes to Abwehr HQ Paris, "Dear France. Your friend Bobby the Pig grows fatter every day. He is gorging now like a king, roars like a lion and shits like an elephant. Fritz." '

They knew of Agent Fritz but not of Bobby. This was because there was no Agent Bobby. Bobby was Chapman's pig who followed him everywhere, responded to his whistle like a dog, rolled over to have his tummy scratched and even went swimming with him.

Bletchley Park knew Fritz was about to be parachuted into Britain. What it did not know was that he was English or that his orders were to sabotage the de Havilland aircraft factory in Hatfield. In 1942, when the flamboyant agent was dropped near Cambridge he went into the nearest police station, declaring he was a loyal British citizen who wanted to work for MI5. He was given the code-name Zigzag.

Dick White's Double Cross Committee was known as the Twenty Committee because the Roman numerals for twenty, XX, form a double cross. Initially it was used for tracking down enemy agents until it proved to be excellent for passing false information to the Germans.

MI5 knew a lot about Eddie Chapman, German code-name Fritz or Fritzchen, long before his arrival in Britain with instructions to blow up the de Havilland factory in Hatfield. Winston Churchill took a personal interest in him. The Germans longed to put Hatfield, which made the much-feared Mosquito bomber, out of action. MI5 decided, with the co-operation of Geoffrey de Havilland, to simulate the sabotage and shopped with Chapman to buy the ingredients necessary for a home-made bomb. Chapman knew a lot about explosives. They were the tools of his trade.

The stage illusionist Jasper Maskelyne, a member of MI9, was called in. MI6 established MI9 to help escaping prisoners of war. MI6 staffed MI9 and ran its escape lines in northern Europe. From his desk in a tiny office below a brothel, Maskelyne invented some of the most ingenious spy devices ever used in warfare. His lectures were famous. By the time the war ended, he had talked to 200,000 officers and men in 12 countries.

Maskelyne made it look from the air that de Havilland's Mosquito plant had been blown up. He made replicas of transformers, painted corrugated iron sheets to look like a massive hole in the ground and replaced the real gates with mangled ones. Buildings were covered with tarpaulin and painted to look like half demolished walls. Real walls were covered with soot and rubble and debris was spread from the 'hole' for 100 feet around it.

Shortly before midnight, Hatfield folk woke to the sound of huge explosion and a scene of devastation. At 5 a.m. Monday 1 February 1943 *The Daily Express* printed a small notice and photographs in the first edition only, the one sent to neutral Portugal, saying, 'Investigations are being made into the cause of an explosion at a factory on the outskirts of London. It is understood that the damage was slight and there was no loss of life.' The Germans took aerial photographs and were pleased with what they saw.

The 'attack' was one of the most remarkable deception operations of the war. On the night of 30 January, a real bomb was exploded inside the factory's power plant. The operation was a complete success, deceiving the factory's own staff.

When MI5 advised him to stay in Britain, Chapman said he was going back to Germany to assassinate Hitler. He was hailed as a hero by the Third Reich, awarded the Iron Cross, given 110,000 Reichsmarks, a yacht and a job teaching in a spy school in occupied Norway. He spent the next fifteen months living in luxury as an Abwehr instructor. One of his lectures was on how he blew up the de Havilland factory.

On 25 June 1944, Chapman was Stephan von Gröning's guest of honour at a lunch given at SS HQ, Paris, before being sent back to Britain to report back on German V1 damage. He gave MI6 vital information on the German Secret Service, weaponry, bomb damage and morale. This time MI5 dispensed with his services because he boasted about his work and had revealed his true identity to his Norwegian girlfriend. He was paid off with £6,000 (£617,000) and all outstanding criminal charges against him were dropped.

Zigzag was the perfect name for double agent Eddie Chapman. He never did go straight. After the war, he became friends with the Kray twins and 'mad' Frankie Fraser, smuggled

gold, sailed to Tangiers where he planned to kidnap the Sultan and passed forged currency. Although up in court many times, he never went back to prison. Newspapers called him the gentleman crook. He called himself an honest villain.

In 1953, when he tried to publish his war memoirs, he was gagged by MI5. Sanitised extracts appeared in the *News of the World*. He tried again in 1966. From this version came the film *Triple Cross* (1967) in which Chapman was played by Christopher Plummer.

On the proceeds of the film, Eddie and Betty Chapman opened a health resort, gym and sauna in the grand thirty-two roomed Shenley Lodge near St Albans, which they ran until 1980. Before her appointment there, Pamela Edginton was the personal hairdresser of Jacqueline Kennedy, widow of President Kennedy who was assassinated in 1963.
It's said that Eddie often held forth in his local pub, The Black Lion in Shenley, about his wartime exploits but they were so fantastic that the villagers did not believe him.

Eddie Wearside, aka Chapman, aka Fritz, aka Fritzchen, aka Zigzag, the only British citizen ever to have been awarded the Iron Cross, died in St Albans, 11 December 1997.

# CHAPTER 25

# KIM PHILBY

## The Third Man

Recruited by Dick White, head of MI6, Philby was appointed head of MI6 Counter Intelligence Section V. He operated out of Glenalmond House in King Harry Lane, St Albans. Section V was the Iberian Section covering neutral Spain and Portugal.

Harold Philby, nicknamed Kim after Rudyard Kipling's boy spy, was awarded an OBE for outstanding services to Britain. As head of MI6 Anti-Soviet Section, he was tipped as a possible head of MI5. He was also a KGB agent. Of the five most infamous spies in history — Burgess, Maclean, Cairncross, Philby and Blunt — Philby did the most damage. By providing classified information to the Soviet Union he caused the deaths of hundreds of British agents.

Philby became a KGB agent in 1934 when he was twenty-two. Graham Greene wrote *The Third Man* in 1948, three years before Burgess and MacLean defected. The third man was Kim Philby. The film, *The Third Man*, set in Vienna, is partly based on fact. In 1934, Philby was in Vienna hiding Communists from the Nazis in the sewers. In the film, Philby's name is Lime, which is, of course, a shade of green.

As a KGB agent, Philby, naturally, was desperate to infiltrate the British Secret Service. Guy Burgess, friend and fellow KGB agent from their Cambridge days, who was already in, suggested he write a paper outlining an idea for establishing special schools to train agents in the art of spying. He did. In 1939, Burgess recommended to chief of staff, MI6 Section D, that Philby be recruited and put in charge of the propaganda training programme for the Special Operations Executive (SOE). Philby was cleared for security because he had never joined the Communist Party.

Out of Philby's paper came SOE's Special Training School (STS) 17, Brickendonbury Manor — the first in Hertfordshire.

In the end, the county had thirty-three of Philby's SOE STS each set up for specific purpose. Brickendonbury near Hertford specialised in industrial sabotage. Philby drew up the training syllabus based on his KGB training by the Russians.

Above: *Glenalmond*
Below: *Brickendonbury*

He was then posted to Praewood House, also in Hertfordshire, where he taught SOE agents the art of black propaganda. One of his trainees was Malcolm Muggeridge.

When based in Glenalmond, King Harry Lane, Philby, his pregnant mistress Aileen and their children, Josephine and John, shared a house nearby with Tim Milne, an old school friend. A popular, dominating presence at Glenalmond, colleagues said Philby had enormous energy, magnetic charm and the boyishness of a boy scout. Very good-looking, with a wonderful smile and engaging personality, he was described as the perfect English gentleman. Here, at least, Philby experienced no conflict of loyalty. At the time, Britain and Russia were equally intent on crushing Germany.

Next door to Glenalmond House was Central Registry where MI6 files, top-secret lists of all agents working abroad were kept. Taking out files relating to Section V was part of Philby's job, but taking out files listing British agents in Soviet Russia was not. Nearly rumbled many times in his KGB career he was very nearly exposed here when a 'Russian' file went missing. As usual, his astonishing luck held.

Malcolm Muggeridge in his memoirs said when Philby's father, a Communist, was interned on the Isle of Man, he gave his son his shabby worse-for-wear First World War officer's army tunic which Philby often wore. Philby adored his father.

In St Albans, Philby, at the centre of power, was one of a very few men with access to ULTRA intercepts from Bletchley Park, the name given to highly secret material from decoded German messages. At Glenalmond, Philby supervised twelve agents including Graham Greene, Malcolm Muggeridge, Ivan Ustinov (father of the more famous Peter) and KGB Agent John Cairncross.

Cairncross met Philby, Donald Maclean, Guy Burgess and Anthony Blunt at Trinity College, Cambridge. All were secret supporters of the Communist Party. When he worked at the Government Code and Cipher School at Bletchley Park, Cairncross passed on codes to the Soviet Union which enabled Soviet spies to change their codes just as British Intelligence was about to crack them. His information about atomic weapons programmes are said to have been the foundation of the Soviet nuclear programme.

Cairncross said he had assumed he was the only KGB agent in MI6. In Section V, he produced, under Philby's directive, an order of battle of the SS. Later, Cairncross would say, probably truthfully, that he had no idea that Philby was a KGB agent.

Graham Greene's niece, Amanda (his sister Elizabeth's daughter), on Parents' Day at her boarding school was dragooned with fellow pupils into a madcap game of hide-and-seek by a parent who, did they but know it, was an expert at the game — Kim Philby.

Philby, Greene's boss in Section V, became a lifelong friend. When Philby defected, Greene visited him five times in Moscow. In a TV interview, Philby talked about their time together in Glenalmond. In Philby's memoirs, *My Silent War,* he praised Greene who wrote the introduction. It's thought that Greene may have left MI6 rather than help expose Philby.

In 1944, Philby helped reorganise MI6. 'C', Sir Stewart Menzies, Chief MI6, appointed him head of Section IX, the anti-Soviet division responsible for counter-espionage against the Soviet Union.

In 1945, Philby divorced his first wife, an Austrian Communist, to marry Aileen.

When SOE was wound up after the war, Colonel David Smiley, one of its heroes, joined MI6. In an attempt to halt the spread of Communism, he briefed 100 agents being sent into Albania. Philby gave their names to the KGB. Caught as they landed by parachute or boat, they were tortured and shot. The carnage haunted Smiley for the rest of his life.

In 1946, Philby was awarded a CBE in the New Year's Honours List. In 1947, he was posted as station chief for MI6 in Istanbul before being promoted to MI6 liaison officer in Washington DC, working with the CIA and FBI.

In 1950, when the possibility of Philby becoming the next director general of MI6 was discussed, Dick White was asked to prepare a report on him. He decided that Philby might be a double agent. In 1951, when Burgess and Maclean defected, Philby became the chief suspect as the man who tipped them off that they were being investigated but MI6 cleared him of being part of a spy ring. However, the CIA insisted Philby be recalled to London.

'Invited [sic]' to 'resign' from the 'foreign office' Philby was paid off with £4,000 (£275,872 today). Then living in Heronsgate near Chorleywood, Hertfordshire, he was asked to attend a mock trial in November 1952 on a charge of high treason to test if there was enough evidence for a real trial. He could have refused but chose not to. He brought his selective stammer into play to engender sympathy. Philby received spot visits to his home for over a month. Sometimes he did not go home for days. Aileen, left with five children in Heronsgate, telegrammed the FCO saying Philby was the third man.

When Burgess and Maclean defected, MI5 found confidential material given to Burgess by John Cairncross in Burgess' flat. Cairncross made a full confession in return for not being prosecuted. From then on, until he retired, he worked for the UN FAO.

On 23 October 1955, the *New York Sunday News* reported that Philby was a Soviet spy. Two days later, Marcus Lipton asked Anthony Eden in the House of Commons, 'Has the prime minister made up his mind to cover up at all costs the dubious third-man activities of Mr Harold Philby?' Eden refused to reply. but, Harold Macmillan, foreign secretary, issued a statement. 'While in government service he [Philby] carried out his duties ably and conscientiously, and I have no reason to conclude that Mr Philby has at any time betrayed the interests of his country, or to identify him with the so-called "Third Man", if indeed there was one.'

At the time, Philby's son John was a pupil at Beaumont House Prep School in Oakwood Drive, St Albans (Guy Burgess also went to a prep school in Hertfordshire, Lockers Park in Hemel Hempstead). John Philby said when the newspapers were full of the 'third man' allegations about his father in 1955, 'My classmates were excited to think my father could be a spy, and the whole thing enhanced my image. When Harold Macmillan cleared Kim's name, the headmaster called me into his study. Looking very pleased, he said: "Good news, Philby, your father's been exonerated".'

Philby called a press conference in his mother's flat to deny he was a spy. He challenged Lipton to repeat his claims outside the protection of the House of Commons. Lipton was forced to withdraw his comments.

Philby moved to the Middle East where he worked as a foreign correspondent for the *Observer* and the *Economist* but continued to work for MI6. When Aileen, forty-seven, died Christmas 1957, the Philby children went to live with an aunt and uncle. In 1963, John Philby was a student in Hornsey School of Art when he read about his father's defection.

In 1964, Anthony Blunt, interviewed eleven times, finally admitted being a Soviet agent and named John Cairncross among those he recruited. In 1967, working as a photographer for the *Sunday Times*, John Philby saw his father in Moscow. Philby always hoped he would be allowed 'home'. He dreamed of living in a cottage in the English countryside with roses round the door. His son said his father's death in 1988, the year before the Soviet bloc began to crumble, was, as ever, 'impeccable timing'. Philby never witnessed Communism abandoned in favour of Capitalism. In 1989, the infamous Berlin wall was dismantled and Philby's ideals were discredited worldwide.

Philby said he was not a double agent because he had never helped Britain in any way. The Kim Philby Club meets every month in Moscow in the flat of his Russian widow.

# CHAPTER 26

# GRAHAM GREENE

## RELUCTANT OAP

Despite a few attempts at suicide, Graham Greene died peacefully of old age in his bed.

Born and brought up in Berkhamsted, he was a boarder at Berkhamsted Collegiate School where Charles, his father, was headmaster.

Terrified of homosexuality among his charges, Charles ran a spy ring of house masters, prefects and matron to keep them under surveillance. As headmaster's son and head boy's brother, Greene's peers accused him of spying on them. How ironic that he did indeed become a spy.

Spying often runs in families. One of nine children, Greene came from a long line of spies, the family was obsessed with 'The Great Game'. His father's brother, Sir William Graham Greene, who also lived in Berkhamsted, helped establish Naval Intelligence. His uncle Edward married a German. Their pro-Hitler son Ben, who wrote propaganda praising the Nazi invasion of Poland, was interned for the duration of the war accused of helping Nazi spies. Greene's brother Hugh was the *Daily Telegraph* correspondent in Nazi Berlin and head of British propaganda in Malaya in 1950. Graham and Hugh published *The Spy's Bedside Book* about the tricks of the trade. They dedicated it to John Buchan who features in the book alongside Compton Mackenzie and their brother Herbert. Herbert was a double agent working for the Imperial Japanese Navy collecting information on USA and UK economic and military strength. He also worked undercover during the Spanish Civil War. Herbert and his sister Elizabeth joined MI6 at the same time. Elizabeth, who married Rodney Dennys, another agent, recruited Graham and Malcolm Muggeridge.

In 1944, Greene wrote a film script, *Nobody To Blame,* poking fun of the British Secret Service. In it Richard Tripp, Agent B 720, invents a network of sub-agents throughout Germany for whom he draws salaries and expenses. The Board of Film Censors refused to grant it a certificate. He rehashed the idea for *Our Man in Havana*, which pokes fun at British Intelligence bumbling around in pre-Castro Cuba. For that, MI6 considered bringing an action against him for breach of the Official Secrets Act.

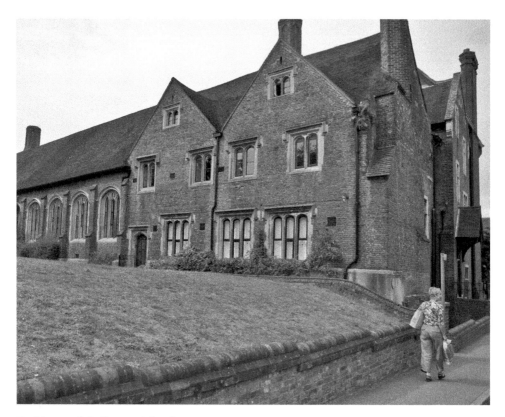

*Berkhamsted Collegiate School*

Greene's sister Elizabeth joined MI6 at Bletchley Park in November 1938 where she met Rodney Dennys. She worked for Captain Cuthbert Bowlby until he became head of Middle East Secret Intelligence in Cairo, where she joined him in the autumn of 1941. Here she met up again with Dennys, who had just had a narrow escape in Holland from the Gestapo, which had him on an execution list. When Elizabeth went to an out-of-bounds section of desert by the Suez Canal to meet a boyfriend, she faced prosecution. Dennys defended her, pointing out that those who reported her must also have been off-limits; they married in 1944.

Dennys' work in intelligence took the family to Egypt, Turkey and France. Elizabeth's war years were spent between Cairo and Algiers where she worked on evacuation plans for Cairo. Letters to her mother from here were used by Michael Ondaatje as background for *The English Patient*.

There is a widely held misconception that Greene disliked Berkhamsted where he spent the first twenty-one years of his life. Not true — he went back many times.

He said as a schoolboy he played Russian roulette on Berkhamsted Common by putting one bullet in the six-bullet chamber of a revolver and rotating it before putting the muzzle in his ear and pulling the trigger. He pinned his abject misery on being a

boarder at the school where his father was headmaster but this presented no problems for his brothers exposed to the same fate. The truth was that, unlike them, he was unpopular. Unlike them, he hated gym, sports and Officer Training Corps (from which he played truant and was beaten).

He found it hard to accept the day and night unremitting lack of privacy (doors without locks in the stinking lavatories), the snores, sweat and smells (neurotically fastidious, he cringed from squalor) of a sadistic peer group. He said it was at school he first experienced the trauma of betrayal. As an adult, however, he would not himself shrink from humiliating others, would also betray those who trusted him and was often gratuitously cruel.

Then there was the problem of his high achieving family. The other, rich, very rich, Greenes: his mother's cousin, acclaimed novelist Robert Louis Stevenson; his uncle who helped start Naval Intelligence; his brothers, happy, hearty, outdoor types (Raymond, an endocrinologist, was the senior medical officer on the 1933 Mount Everest expedition).

At university, Greene was drunk most of the time (on one occasion friends had to carry him, mid-morning, into an interview). For a man who lived a life so full and so exciting, barely imaginable to those even with vivid imaginations, to call his autobiography *A Sort of Life* beggars belief. (The Graham Greene Society publishes *A Sort of Newsletter.*) Berkhamsted appears in *The Human Factor*.

Sent by MI6 to Freetown, Sierra Leone — the setting for *The Heart of the Matter* — instructed to recruit spies, Greene suggested using a brothel as bait. He knew all about brothels. His numerous affairs — inside and outside marriage — included, by his own admission, relationships with forty-seven prostitutes. His proposal was turned down.

Greene drew on his experience with British Intelligence to write many spy novels, including *The Quiet American* (1952), set in Southeast Asia; *A Burnt-out Case* (1961), about the Belgian Congo; *The Comedians* (1966), set in Haiti; *The Honorary Consul* (1973), set in Paraguay; and *The Human Factor* (1978), about spies in London.

There is a Graham Greene Birthplace Trust Festival every year in Berkhamsted.

# CHAPTER 27

# MALCOLM MUGGERIDGE

## SAINT MUGG

Graham Greene's sister Elizabeth married Rodney Dennys. Both were intelligence agents. When Greene told Malcolm Muggeridge about the couple, Muggeridge asked him to use his influence to get him a posting overseas. Elizabeth did better than that. She recruited them both.

They were sent to work for MI6 in Section V responsible for counter-espionage abroad. Greene's job was to supervise Counter Intelligence in neutral Portugal. At the secret location for Section V, Glenalmond House, King Harry Lane, St Albans, their boss, highly efficient despite his alcoholism, was the charismatic Kim Philby. Muggeridge said that sometimes Philby's stutter was so bad that he had to gasp to get his words out, clawing the air. Other accounts of Philby say his stammer was selective and used to engender sympathy. Muggeridge, in his memoirs, said he received his initial MI6 training with Philby in nearby Prae Wood House, St Albans.

Muggeridge said MI6 was a 'frowsty old intelligence brothel which ravaged and corrupted the innocent American new recruits to Section V'. Section V frequented The Chalet, a local restaurant, and often played cricket after work. Also in Section V was KGB Agent John Cairncross. Recruited at Cambridge by Anthony Blunt, he was at Trinity with Kim Philby, Donald Maclean and Guy Burgess. His leaks about Bletchley Park enabled the Soviets to change their codes just as British Intelligence was about to crack them. His leaks about British and American atomic weapons are said to have launched the Soviet nuclear programme. In 1944, exhausted by spy work at GCHQ, he was posted to MI6 Section V, unaware that Philby was a double agent. In 1964, Cairncross made a full confession in return for not being prosecuted. He worked for the UN FAO until he retired. He died in 1995.

Another of Philby's agents in St Albans was Ivan Ustinov, father of the more famous Peter. Although spying often runs in the family, Peter Ustinov said in his memoirs that his father refused to let him join the secret service because the British government treated him shabbily over his service pension.

Both Greene and Muggeridge were posted to Africa where they worked as a double act for a time. Muggeridge, Marxist, atheist, satirist, womaniser and born-again Christian, was called a hypocrite when he attacked the Monty Python team on television over their film *The Life of Brian*.

When MI6 left Glenalmond, it became the HQ for Operation Sussex, training French agents in intelligence gathering prior to D-Day. Glenalmond is now a nursery school — for children, not secret agents.

# CHAPTER 28

# BARNES WALLIS

## THE DAM BUSTER OF WATFORD

2008 marked the sixty-fifth anniversary of the legendary Dam Busters Raid — the most daring feat in aircraft history.

The first test on how to breach the biggest dam in the Ruhr Valley, the Möhne, was carried out in secret in Watford.

When Hitler's military ambitions became clear, the British government drew up a plan to paralyse the dams in the Ruhr valley. Air Intelligence had reported that water used in the whole of Germany was only three times that of the Ruhr and that the bulk — 30 billion gallons — was from one reservoir alone contained by the Möhne.

Completed in 1913, 2,100 feet long, 112 feet high with a base of 130 feet tapering to 25 feet, its reservoir, which supplied hydro-electric power and water to industry, would soon be supplying factories turned over to the manufacture of — to use a phrase from a very different war — weapons of mass destruction. Britain's objectives were: cut water supplies; cause flooding and damage to industrial plants, rail tracks and waterways; prevent supplies of water for use in inland waterway systems.

When the government's Bombing Committee, Paper 16, was circulated it described the construction and siting of the dams and the fact that to deter torpedoes the Germans had spread nets over the water in front of the dams; the Möhne was also very well protected by anti-aircraft guns. The plan to generate a man-made tsunami was now on the table — the problem was that no one had any idea how to carry it out.

Enter Mr Barnes Wallis, Assistant Chief Designer at Vickers Armstrong Aviation. Considered a genius by his peers, Wallis was living proof that not going to university need be no drawback in life. After leaving school he was an apprentice with Thames Engineering in Blackheath before starting work with a shipbuilder on the Isle of Wight. When he was twenty-five, an opportunity arose which enabled him to work for Vickers (and its successor British Aircraft Corporation) where he stayed until he retired. He worked on the Vickers Wellesley and Wellington using his geodesic invention (as seen in

The Eden Project) which provided a lighter, stronger frame compared to conventional constructions. It was not until he was thirty-six he decided to enrol for an external degree in engineering with the University of London.

Wallis knew Dr William Glanville of the Road Research Laboratory on the Colnbrook bypass in Harmondsworth. Discussing the challenge of breaching the dams. Glanville suggested Wallis meet his close family friend, Dr Norman Davey of the Government Building Research Station (now BRE) Bucknalls Lane, Garston, near Watford.

Just before Christmas 1940, at the height of the Blitz (blitzkrieg — saturation bombing of London) when it looked extremely likely we might all soon be German citizens, Barnes Wallis visited Dr Davey in his office at Watford for a top-secret meeting. A report by Dr Davey of this historic day is in BRE archives.

Today, Dr Davey is remembered in Hertfordshire for the restoration of Romano-British wall paintings at Verulamium, St Albans that launched the systematic study of wall painting in Roman Britain, but when he met Barnes Wallis he was revered as the structural engineer who designed the world-famous acoustic dome in the Royal Albert Hall. It was while working at Garston that Dr Davey became interested in archaeology and became involved with Sir Mortimer Wheeler and his excavations at Verulamium.

Barnes Wallis and Dr Davey decided that the best way to test where to hit the Möhne and how big a bomb was needed to breach it was to build a small-scale model of the dam. Over the next two years, there would be many other tests at many other locations, but this first one was very important because it demonstrated what could and could not work.

Using plans and technical data published in Germany when the dam was built in 1913, Dr Davey designed a tiny replica of the Möhne. During January and February of 1941, in severe winter weather and in extreme secrecy, a 3-foot-high, 42-foot-long model was built behind the Building Research Station (in part of Bricket Wood). Garston Research Station cast 2 million specially manufactured to scale miniature mortar blocks (10.2 x 7.6 x 5.1 mm) around a concrete core. These were taken to the secret location by hand in buckets. Dr Davey built his model across a stream so that the upper face of the dam could be submerged to simulate actual conditions. It took his team seven weeks to build. When miniature explosives were used in the tests, it was concluded that to breach the dam it would take 6,000 pounds of explosive detonated against the wall 30 feet down when the reservoir was full.

The daring raid on the Möhne Dam in May 1943, one of the best known of the war, was carried out by 617 Squadron RAF Bomber Command. It would be the end of 1954 before the Air Ministry would acknowledge Dr Davey's crucial involvement in the heroic event. When *The Dam Busters* was being filmed, Dr Davey invited the Associated British Picture Corporation to BRE to see his model. The film company was not interested.

Wallis knew that conventional bombs were not accurate enough to hit the target. Needing a new kind of bomb to breach the dam from the air, he came up with an ingenious idea: one that would bounce over the torpedo nets.

*Model Möhne Dam: BRE Watford*

It had been known since the 1800s that cannon balls increased range when bounced on water, but he needed a bomb which would not only bounce over water but one which would hit the target and then sink before exploding on par with an earthquake (in golf a Barnes Wallis is a shot that bounces over a water hazard). He began working on a bomb with backspin, which if dropped low (turned out to be 60 feet — any higher it wouldn't bounce) at an angle of seven degrees from the horizontal at 220 mph would skip over the surface of the water in a series of bounces before hitting the dam wall. After impact, it would roll down the underwater face. Once it reached a certain depth, it would trigger an explosion which would detonate the main explosive charge. The shockwave would demolish any target above and for some considerable radius.

Barnes Wallis carried out initial experiments in his garden using his children's marbles fired from a home-made sling across tin baths of water but in the end plumped for a cylindrical as opposed to spherical bomb. Gone down in British history as 'The Bouncing Bomb', the Germans called it a revolving depth charge.

Two years after the Garston tests in Watford, Wallis attended a meeting at Vickers Armstrong and convinced the Ministry of Aircraft Production that the concept of skipping a bomb onto the dam face was feasible. His report was read by Sir Arthur (Bomber)

Harris who said it was 'tripe... not the smallest chance of it working'. Wallis was hauled over the coals by the chairman of Vickers, who told him to stop making a nuisance of himself and drop the whole idea; Wallis offered to resign.

Two days later, he was summoned to another meeting with the Ministry of Aircraft Production and told that the chief of Air Staff wanted his project to go ahead.

Its success is still being argued over. Eight of the nineteen planes used in the raid were lost, fifty-three men died, three were captured and sent to camps. Not in doubt is the astonishing heroism of the young crews.

It took 7,000 men — mainly slave labour — just four months to rebuild the breached dam wall but the power station at the base was never rebuilt.

As for Barnes Wallis' bouncing bomb, although it was kept secret in Britain until well after the war, the morning after the raid it was examined by experts and a report from Albert Speer was sent to Herman Göring. An inferior German version, code-name Kurt, designed to be used against British shipping was never used.

The RAF has no idea how many survivors of the famous raid are still alive. Not all want to be reminded of the horror of war, others shun publicity but Ionaca art gallery in Chorleywood knows four. One of their artists, Martin Bleasby, took a photograph of three aircrew and one ground crew when they were signing prints of his painting, 'Target in Sight'. They are Flight Lieutenant Les Munro, DSO, DFC, RNZAF, the last surviving pilot, one of the three flight commanders; Squadron Leader George 'Johnny' Johnson, DFM, who, after ten attempted runs into the Sorpe dam, released his bomb and scored a direct hit but the dam was not breached; Sergeant Raymond Grayston, Flight Engineer on the aircraft that successfully breached the Eder Dam, who was shot down during a later raid and taken prisoner of war; Corporal Ken Lucas of 617 Squadron, a member of ground crew who was involved in carrying out modifications to the Lancasters right up to the night of the raid.

In 1997, when there was speculation that part of the BRE site was to be redeveloped and the historically important model might be under threat, the Barnes Wallis Memorial Trust offered to dismantle it and provide a home for it in the Yorkshire Air Museum; it thought it a shame the museum's 40,000 visitors a year can't see it (the model is not open to the general public). Although the bid was unsuccessful, attention was drawn to the fact that the model was not in good repair and should be listed. It has now been scheduled to save it from destruction.

Sir Barnes Wallis died in 1979 age ninety-two. His memorial service in St Paul's was attended by the Prince of Wales. When his daughter Mary married Marie Stopes' son Harry, Marie Stopes cut him out of her will because Mary Wallis wore glasses. A devotee of eugenics, Stopes did not want grandchildren with eye defects. Dr Norman Davey, FSA, died in 2002 age 102.

# CHAPTER 29

# SUE RYDER

## Lady of Warsaw (and all those Charity Shops)

During the Second World War, Sue Ryder joined the First Aid Nursing Yeomanry (FANY) because, she said, she didn't fancy the Land Army. Her training included codes, sabotage, secret ink, microscope photography and radio communications. FANY supplied over half the personnel needed to run Special Operations Executive (SOE) Special Training Schools (STS) to train agents and resistance workers in industrial sabotage. Thirty-three STS were in Hertfordshire.

STS 38, Briggens (now flats) near Roydon, SOE Forgery Section held Poles. It was the ancestral home of Lord Aldenham, chairman of Westminster Bank, who stayed there throughout the war. His son was killed in action.

The first SOE STS for training in 'ungentlemanly (guerrilla) warfare' in the county was Brickendonbury (STS 17) in July 1940. Another STS, ironically, was Shenley Lodge (now Manor Lodge School). Ironic because double agent Eddie Chapman, aka Zigzag, bought Shenley Lodge after the war.

SOE Bods (bodies) were trained in secret warfare. Among them were graphic artists — ex-Bank of Poland employees who forged identity papers, passports, ration books, currency, any documents used in occupied Europe.

FANY nurses, mainly young, attractive, cultured, hard-working and friendly were unpaid volunteers. They drove Bods around, cooked for them and danced with them. SOE agents said the experience was a cross between school and a first class hotel where the huntin', shootin' an' fishin' were free.

FANY, in charge of ATS driving units, taught Princess Elizabeth (HM Elizabeth II) to drive. They drove lorries and ambulances, ran soup kitchens and transmitted encoded and decoded messages to and from the field.

Sue Ryder later served in North Africa and Poland but her initial training was at STS 17, the eighteenth-century Brickendonbury manor house near Hertford. SOE, dubbed Stately 'Omes of England, requisitioned country houses in mainly rural, inaccessible areas.

No contact with the locals was allowed, who were told they were training schools for Allied commandos.

Sue Ryder was trained in the following: first aid, use of small arms, signals, ciphers, Morse code, wireless, parachute packing, map reading and use of plastic explosives (similar to Semtex); there was also the following: drill, inspection, route marches, fire drill, stretcher drill, mock interrogations, subversive activities against Germans occupying the UK, and mechanics. FANY maintained their own vehicles in first class condition. They could be cars or 7 tonne lorries. There were written and oral examinations in all these subjects.

FANY's had fun too. They rode the country lanes on the Welbike designed at The Frythe in Welwyn. These were collapsible motorbikes which they packed into containers to be dropped for agents in enemy-occupied territories. One can be seen in Harrington Aviation Museum in Northampton.

FANY's tested explosives on nearby airfields, railway stations, military stores and engine sheds in Hitchin.

Each STS was set up for a specific purpose; Brickendonbury's was industrial sabotage. Brickendonbury, a seventeenth-century mansion requisitioned at the outbreak of war, is where Francis Cammaerts did his initial training, where double agent Kim Philby wrote the training syllabus in sabotage based on his own training by the Russians in 1933 and where Ian Fleming visited to see James Bond-style gadgets used by agents.

It's thanks to George Rheam, an engineer in the steel industry who ran Brickendonbury, that Hitler's plan for the atom bomb was shelved. He trained the men who carried out the astonishing raid to destroy the heavy water plant (Germany's nuclear bomb programme) in Oslo.

The rehearsal for the assassination of SS Reinhard Heydrich was also carried out at Brickendonbury; it was Heydrich who organised the Holocaust.

On 27 May 1942, a Czech agent, part of a team of parachutists trained by SOE, threw a bomb at the Mercedes Heydrich was travelling in. The assassination provoked ferocious reprisals against Czechs and Jews resulting in the total obliteration of Lidice and the massacre of its inhabitants.

A TV documentary, *The Secret War,* showed archive film of Brickendonbury. As late as 1973 unexploded hand grenades and live mortar shells were still being found in the moat.

After her initial training, Sue Ryder transferred to one of the Polish divisions of SOE, Frogmore Farm (now Frogmore Hall), STS 18 at Watton-at-Stone. Professor Michael Foot says its well-stocked bar helped staff find out how well or not potential agents could handle alcohol.

Bods (bodies), known by surnames only, supposedly Allied officers who were supposedly recuperating from injuries and convalescing, were the agents who helped resistance fighters. After the war, Sue Ryder called residents in her Residential Homes Bods in their honour. FANY's cooked for them, packed lunch-boxes, drove them to airfields to

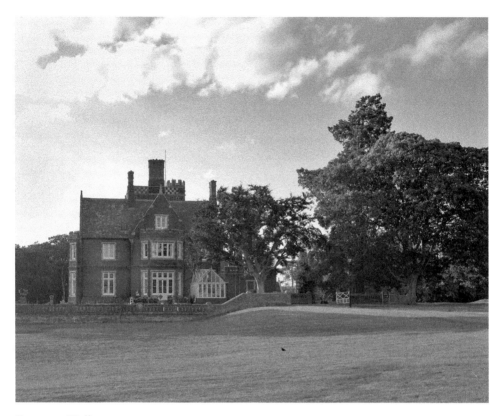

*Frogmore Hall*

be dropped in enemy-occupied territory and waited for their return. Some FANY's were themselves dropped carrying information, arms and wirelesses.

At Watton, a locally employed washerwoman told agents she had just seen her first shirt button melt in the wash. It was the cyanide pill sewn into Bods shirts for self-administering if caught by the Germans. Secrecy being paramount, her services were dispensed with. Some agents had the tablet inserted under the skin on the hand to make it easier to get at it if it were needed urgently.

During the war, Sue Ryder met people of such superhuman courage and saw suffering on such a scale she vowed that, when the war was over, she would found a living memorial to commemorate them. The Sue Ryder Foundation, which started in 1953, transformed the lives of hundreds of thousands of people.

In 1948, when Leonard Cheshire VC inherited a house in Hampshire, he was asked by the local hospital to take in an ex-serviceman dying of cancer. By 1952, he had opened four homes but by then was himself ill with TB.

In 1955, Cheshire, of whom (although he was a national hero, one of the most famous airmen of the war and a household name) Sue Ryder had never heard, invited her to his newly opened home in Ampthill in Bedfordshire, one of eighty homes at a time when the

disabled were excluded from society and not talked about. Baron Cheshire himself laid the foundation stone of his care home in St John's Road, Hitchin.

When the arranged day in a freezing February dawned, Sue Ryder was suffering from a kidney infection but was determined to keep her appointment. On arrival, she found the gates locked so, ill and cold, was tempted to go home, but, realising these were the gates leading on to the park, she pressed on. Within minutes, although neither was to know it, each had met their soul mate. The couple talked about plans for their respective ventures, became trustees in each other's charity and married four years later.

Sue Ryder decided her monument must be via practical help to those worse affected by war, a living memorial. She started house hunting for a holiday home for survivors from Nazi-occupied countries, Auschwitz and Ravensbrück. Groups travelled by rail to England. The Red Cross provided food along the way. The ferry to Dover was met by Sue Ryder until 1979 when the scheme ran out of money.

In 1969, Sue Ryder bought Stagenhoe near Hitchin from the Countess of Caithness. Built in 1737, it had thirty-three bedrooms and nine acres. It was here, in 1887, Arthur Sullivan wrote *Mikado* and invited the Doyley Carte Opera Company for weekends. It was here the HM Queen Mother, as a little girl, played with the Bailey Hawkins children (she was brought up in nearby St Paul's Walden). In 1988, the Queen Mother opened the new wing.

# CHAPTER 30

# FRANCIS CAMMAERTS

## CODE-NAME ROGER

In the 1950s, how many staff or pupils of Thomas Alleyne School in Stevenage knew that their headmaster, Francis Cammaerts, led an army of 10,000 resistance workers at the time of the D-Day landings?

Francis Cammaerts, DSO, grew up in 'Eyrie', 3 Hillside Road, Radlett, where he lived for twenty-one years. He went to school in Harpenden. After the war he was appointed headmaster, Thomas Alleyne School, Stevenage Old Town.

Cammaerts, SOE agent, code-name Roger, is said to have been the most popular Englishman in France during the war, and he was decorated by General de Gaulle personally.

His father was Emile Cammaerts, the Belgian poet laureate who was professor of Belgian Studies at the University of London. His English mother was Helen (Tita) Brand, a Shakespeare actor. Francis, his two older, two younger sisters and a younger brother were bilingual.

Horrified by the carnage of the First World War, Cammaerts started the second a pacifist. He ended it one of the most famous and most successful secret agents in SOE, which organised guerrilla operations against the Nazi occupiers and the Vichy regime.

When war was declared, as a registered conscientious objector he worked for the Lincolnshire Peace Community at Holton Hall Farm where he met his wife Nan Broadbent, sister of Roy Broadbent, one of the farm's founders and father of the actor Jim Broadbent. Another founder was Edmund Albarn, grandfather of Damon Albarn (pop group Blur), who often stayed with him at Holton Hall. As an architect, Edmund Albarn was stripped of his professional qualification because of his pacifist views. Damon Albarn is a peace campaigner.

Following the birth of his first child and the death of his brother in the RAF, Cammaerts changed his mind about the war and was recruited into the SOE in 1942. On the paramilitary training course, staff said he did not have leadership qualities. He spent the rest of the war in France leading thousands of resistance fighters.

*Thomas Alleyne School*

He was flown into occupied France to set up a network of resistance fighters from Lyons to the Mediterranean and to the Italian and Swiss frontiers. When he got to St Jorioz, near Annecy, where other leaders were holed up, the set-up seemed dangerous, so he did not stay. He went to the south of France using the initial cover of a French teacher on sick leave recovering from jaundice. From there, he built up his own circuit, code-name Jockey, and carried out sabotage missions such as blowing up railway lines in the Marseilles area to disrupt German troop movements. Chief of all resistance forces on the left bank of the Rhône, with the rank of lieutenant-colonel, Cammaerts organised secret assistance to the Allied landing on the Riviera coast in mid-August.

He said that once an SS patrol searched him and his car, found nothing and waved him on. The boot — which they did not open — was full of arms and ammunition. On another occasion, when he got out of a train at Avignon, Control spent so long inspecting his papers he became alarmed so started to cough, bit his lip and spat blood on to the platform. The Nazis, terrified of TB, sent him on his way.

Cammaerts insisted that all those who worked with him must at all times have a credible explanation of their actions if they were arrested. If travelling in a car at night, they had

to be a doctor or something similar. His agents were forbidden to use the telephone or go into 'black' cafés to eat black-market meals.

He built up his organisation by adhering strictly to his SOE training. He never spent more than three nights in the same house and, whereas he could contact resistance workers, nobody knew how to reach him except by using human letter boxes — a person with whom one could leave a message to be collected by another giving the right password.

When Cammaerts told HQ in London he needed a woman courier, they sent Christine Granville. The pair, said Patrick Howarth (SOE agent) in *Undercover,* was perfectly matched in integrity and bravery. Christine, a Polish countess, twice captured by the Gestapo, was so plausible she was let go on both occasions.

Cammaerts' big disadvantage for a spook was that he was six feet and three inches tall. On 11 August 1944, posing as a highways and bridges department worker, he was recognised at a snap road control, taken to the Gestapo HQ and sentenced to death three days before the Allies were due to land in the south of France. With astonishing courage, Christine Granville bribed his captors to let him go. Fearing he would be shot before the Allies arrived she went to see the liaison officer between the French and the Gestapo. She told him the Maquis, the local French Resistance, knew about the arrest and would get him killed unless he released Cammaerts; she also convinced him she was General Montgomery's niece and Cammaerts' wife. She argued for his release for three hours, after which she was asked for two million French francs. SOE in Algiers parachuted the money in to her. She was awarded a George Medal, Cammaerts the DSO.

After the war, Christine, when working as a ship's stewardess, had an ardent admirer. Back home in London, the man stalked her for months before stabbing her to death in 1952.

After the war, Francis Cammaerts ran the UNESCO Bureau for Educational Visits and Exchanges before becoming head of Thomas Alleyne School, Stevenage, from 1952 to 1961. He then went to Kenya where he was Professor of Education at Nairobi University before returning to England as head of Rolle Teacher Training College in Exeter (now part of Exeter University).

Cammaerts, who said that MI5 and MI6 desk men in suits were the stupidest people he had ever known, died in France, where he lived near Montpelier among former members of his SOE circuit. His file HS9/258/5 can be viewed online at the National Archives, Kew.

Contact with occupied countries stopped when British forces arrived back in the UK in 1940. The first to return was parachuted in. SOE was set up to enable resistance fighters to sabotage German efforts, lower German morale and stop the manufacture of the H-bomb. Winston Churchill, frustrated by the bureaucracy of the armed forces, started SOE to circuit delays and inefficiencies. In the early days, recruits were from the Old Boy Network, traitors Kim Philby and Guy Burgess among them.

SOE attracted resourceful individuals such as Francis Cammaerts. Quick and instinctive, some seemed telepathic. Intuitive and self-disciplined, they preferred making

their own decisions rather than take orders. They operated better on their own and were not interested in status. Those who worked for SOE, even if they were husband and wife, never told a soul about what they did; only now are inklings of their astonishing heroism being revealed.

When France signed an armistice with Germany in 1940, Hugh Dalton, Minister of Economic Warfare, wrote to Lord Halifax, Foreign Secretary, suggesting, 'A new organisation to co-ordinate, inspire, control and assist the nationals of the oppressed countries who must themselves be direct participants'. Churchill agreed and asked Dalton to head it. This new organisation, set up for espionage and sabotage behind enemy lines, became Section D (Destruction) detached from MI6 to form part of the new SOE.

When Dalton was given an office at 64 Baker Street, SOE, Churchill's Secret Army was dubbed The Baker Street Irregulars after Sherlock Holmes of 221b Baker Street, who used street urchins as his eyes and ears. Holmes said, 'There's more work to be out of one of those little beggars than out of a dozen of the force... These youngsters... go everywhere and hear everything. They are as sharp as needles, too; all they want is organisation.'

Major General Gubbins, head SOE, had been in charge of resistance in the UK to German occupation. He had trained 3,000 guerrillas and had stocks of commando knives, truncheons, radios, grenades, rifles, Tilley lamps and food.

Agents, known only by code-names, were trained how to transmit Morse code, write in code and how to survive alone. Only those who volunteered were sent on operational missions. Special Training School (STS) 38 was Briggens near Royden, Station VI was Bride Hall, Ayot St Lawrence. Professor Michael Foot says that Bride Hall, the SOE armoury for pistols and revolvers, supplied up to 5,000 fully serviced weapons a month. He also says that Gardner's End at Ardeley between Stevenage and Buntingford is where SOE kept German prisoners of war.

Des Turner, Aston resident, has written two books about Aston House, SOE Station 12, which has, unbelievably, been demolished. It was responsible for the design and supply of equipment used in sabotage by the Resistance, Commandos, Special Boat Service and SAS. A huge moated stately home, Aston House was built in the 1500s set in 80 acres near Stevenage; it was second only to SOE HQ in London. Also at Aston House was the radio station transferred from Bletchley Park.

The Natural History Museum, SOE Station 15b, consisted of six sealed rooms full of devices available to agents. Explosives and grenades were hidden in mock-ups of everyday items such as lumps of coal, vegetables and building rubble. Transmitting sets were hidden in portable gramophones, artists' paint boxes, adding machines, bathroom scales, car batteries, armchairs, cement sacks, vacuum cleaners and tool boxes.

Station XV — The Thatched Barn near Borehamwood — was the camouflage station run by a film director and prop makers. A fake tree trunk might conceal radio equipment; stuffed rats hid booby traps which could blow tyres off enemy trucks; exploding turds included donkeys, horses, cows and camels.

The Thatched Barn, a road house built in 1927, was frequented by stars from nearby Elstree Studios. After the war, it was bought by Billy Butlin. In the 1960s, it became a Playboy Club. In 1989, it was The Moat House Hotel. A Holiday Inn is now on the historic site. Other mansions taken over included Wall Hall on the Gorhambury estate.

The False Documents Section was where agents collected bogus identities. A fashion company kitted out agents with clothes cut in Continental style. Attention to detail was vital, particular attention given to labels, zips and buttons. To make the clothes look worn they were distressed.

If agents couldn't remember a message, they wrote it on tissue paper. Inserted into a cigarette, it could be easily destroyed. Agents, chosen for their ability to speak the language of the country in which they were to be dropped, were given Benzedrine pills to keep them awake and the 'L' — a lethal cyanide pill they could bite if about to be captured and could not face the prospect of torture. One of the greatest causes of fear was the brutal paramilitary force in France which rode around in fast, black Citroëns. They worked with the Germans to hunt down SOE agents and anyone who helped them. The Gestapo offered £5,000 for each agent handed in.

Agents were sent to any country under the occupation of Nazi Germany including France, Belgium, Netherlands, Poland, Denmark and Yugoslavia. The SOE was particularly active in helping the French Resistance.

When SOE was wound up after the war, the SAS took its place.

# CHAPTER 31

# MADELEINE DAMERMENT

## AND HITCHIN CONVENT

Madeleine Damerment was born in 1917 in the Pas de Calais to Charles and Madeleine (née Godin) Damerment. The family moved to Lille when Charles was appointed Postmaster. Recruited into the SOE, code-name Martine Dussautoy, her cover was a lay teacher at the Sacred Heart Convent School in Verulam Road, Hitchin. She died in Dachau concentration camp. Her name is on the FANY memorial on the wall of St Paul's church in Kensington. The convent itself has long gone, but as late as 1971, nuns were still living in the two large Edwardian houses, St Katherine's and St Margaret's opposite where the convent once stood in Verulam Road.

Miss Damerment's once secret file HS9/1654, which can be seen at the National Archives in Kew, contains original documents relating to her life and death including moving letters from her mother Madeleine and Charline, her sister.

Because SOE did not officially exist, Madeleine was drafted into the Field Ambulance Nursing Yeomanry (FANY). Like the most famous of the female SOE agents, Violette Szabo and Odette Churchill, Madeleine was captured and tortured. Violette, like Madeleine, was murdered by the Gestapo, but Odette survived.

Thirteen FANY SOE agents parachuted into enemy-occupied territory to help resistance movements died in concentration camps. The most famous was Violette Szabo, GC — the half-French daughter of a Brixton car dealer. The film *Carve Her Name With Pride* recounts her life. Leo Marks, head of SOE, Codes Section, who as a schoolboy compiled cryptic crosswords for *The Times*, briefed agents on the use of codes. He wrote the beautiful poem 'Yours' for his boss's daughter, with whom he was in love. She was killed in an air crash. He then gave it to Violette Szabo as her code poem. Original poems were used as ciphers by agents rather than well-known poems, as they had less chance of being decoded by the enemy.

The story of how a young woman from Lille wound up teaching in Hitchin is absorbing and tragic. That is, of course, if she really was there. A boarder at the school during the

war has no recollection of her. The convent school had 120 pupils of whom 30 were boarders. Sister Marie-Desiree, Sister Celine-Marie and Sister Colomba were still there in 1950 so must have known Madeleine.

In 1940, when Germany occupied France, some British soldiers, those not rescued from Dunkirk, were stranded. A Belgian doctor, Albert-Marie Guérisse, code-name Pat O'Leary, set up an escape line from the north of France to Marseille over the Pyrenees to Spain. It was dubbed the PAT Line.

When British airmen were shot down over France, Charles Damerment harboured them, providing food, clothes and false identity papers at enormous personal risk and fully aware of the consequences of discovery. When the Gestapo started asking questions he told Madeleine and Charline to leave Lille. They went to Toulouse where Madeleine met and became engaged to Roland Lepers, a PAT courier. MI6 knew of them both. Madeleine's father was interned.

When the PAT line was betrayed, to escape arrest, Madeleine and Roland crossed the Pyrenees and made their way to neutral Barcelona, where they decided it would be safer if they separated. Madeleine was arrested, but Roland escaped to England; he joined the French air force and survived the war.

The British got Madeleine out of prison and flew her to Whitchurch near Bristol. At her interview, she told MI5 that she did not want to join de Gaulle's Free French but would prefer to join SOE and become a British agent. Her uncle (her mother's brother) Jean Godin lived in Romilly Road, Cardiff, so she stayed with him until she arrived at the Sacred Heart Convent School in Verulam Road. Her Mother Superior, Sister Magdalen, was still there in 1951. Madeleine was now Martine Dussautoy.

In 1942, Churchill gave permission for women in the SOE to be sent into occupied Europe. Women were less conspicuous than men and expected to be out and about, whereas the Gestapo was suspicious of men on the streets.

Women used as wireless operators took a short-wave Morse transceiver that could send and receive messages. It weighed 30 pounds and fitted into a small suitcase. The main problem was that it needed 70 feet of aerial. In towns it would take the Germans just half an hour to discover where the transceiver was being used, so, where possible, agents worked in isolated areas. They were under instructions to transmit briefly, at irregular intervals, at various wavelengths and from various places. Each agent was instructed to always spell certain words incorrectly so that if captured and the operator used the transceiver to trap other agents, SOE in London would know and could warn them.

Agents were told that, if captured, they must try to stay silent for forty-eight hours when interrogated by the Gestapo. During that time, all the people who had been in contact with the agent moved house and covered their tracks.

When Churchill ordered the RAF to make aircraft available for SOE, Vera Atkins recruited Madeleine into F (French) Section, one of only thirty-nine women, as a radio courier for the 'Bricklayer' network. When Madeleine wrote her will, which Ms Atkins

witnessed, she appointed as executor Mother Superior, St Mary's [*sic*] Convent, Hitchin. With her experience in the Resistance in France, she knew better than her SOE trainers what Nazi Occupation meant.

138 and 161 Special Duty Squadrons (SD) were based at SOE's main flying base at Gibraltar Farm, Tempsford in Bedfordshire to carry out covert supply and agent delivery operations for the SOE and SIS (Secret Intelligence Service). By the time stage illusionist Jasper Maskelyne of MI9, the genius behind the 'bombing' of the de Havilland factory at Hatfield, finished with it, Tempsford looked nothing like an RAF airfield. It was a busy working farm with tractors, duck ponds and cowsheds. The runways stretched through cabbage fields. No wonder the Germans, despite aerial photography, could not locate the base.

Pilots had to have a minimum of 250 night-flying hours. Outbuildings of Gibraltar Farm were converted into high-security SOE stores. The farmhouse became an agent reception and pre-flight preparation centre. SOE sent its first woman agent into France in May 1941.

RAF Tempsford was opened for SOE clandestine operations into occupied Europe. 138 and 161 Special Duties Squadrons were devoted to secret operations. 161, designated to drop agents into occupied territory, was commanded by Wing Commander Fielden, nicknamed Mouse, who had been George VI's personal pilot. The king and Queen Elizabeth visited Tempsford. Both Squadrons suffered losses of planes and men. 161 Squadron lost forty-nine planes. In March 1944, four crew members died when a Hudson of 161 Squadron crashed on training flight.

Lysanders left on full-moon nights and nights when the moon was well up in the sky to land in occupied France to deliver or collect agents, known as 'Joes' ('Joe Soap' always got the worst jobs). Joes arrived at the airfield an hour before take-off to be searched for incriminating evidence such as bus, tube or train tickets and were fitted with parachutes. The drop was about a five-minute turn around.

The SOE sent 470 agents into France, including thirty-nine women. 200 agents lost their lives, most executed on instructions from Hitler in September 1944 and March 1945.

Nearby Hazells Hall, built in the 1700s, was requisitioned in May 1942 from Francis Pym, M.P., and used as a hostel for the pilots and SOE stores. Arms, ammunition, radios and other supplies were delivered to Resistance Groups. Thousands of metal containers of whatever had been asked for were dropped right up until the end of the war, anything from tools, money, forged documents, food, clothes, compasses, torches, batteries, first aid kits, medicines, cigarettes, soap, boots and folding bikes. Pilots flew over French coasts low enough for radio contact with agents in the field. Agents were dropped at around 700 feet.

The BBC used personal messages on its French programme to confirm that a parachute operation was scheduled for that night. A further message on the 9.15 p.m. programme confirmed the operation or, by its absence, its cancellation. In winter, when aircraft frequently left their bases before 9 p.m., the message constituted an order to the reception committee to hurry to the field.

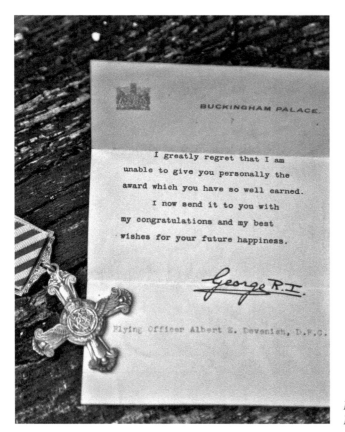

I greatly regret that I am unable to give you personally the award which you have so well earned. I now send it to you with my congratulations and my best wishes for your future happiness.

*George R.I.*

Flying Officer Albert E. Devenish, D.F.C.

*Flying Officer, Albert E. Devenish (John) DFC*

Before take-off, agents were given a silver cigarette case to pawn if necessary and a cyanide pill to take if they didn't think they could face torture. Before take-off, ground staff called out 'Merde!' in much the same way actors say 'break a leg'.

On 29 February 1944, Madeleine Damerment, the finest courier in training, was dropped in France to a reception committee supposedly organised via wireless by fellow SOE Agent Nora Khan. But Nora had been captured. It was a trap.

Her flight had been delayed for several days because of bad weather, but, on the evening of 29 February 1944 a BBC broadcast advised the reception committee to prepare to receive three agents taking off at 9 p.m. from Tempsford for Rambouillet between Paris and Rennes. Vera Atkins was on the tarmac to wave Ms Damerment off. The pilot reported back that the reception committee's lights on the ground had been particularly good. The Germans made sure they were.

Among the flight crews based at Tempsford who dropped SOE agents into occupied France, Norway and Belgium was Flight Engineer Albert Ernest Devenish DFC of 161 Squadron (always known as John). Instituted in 1918, the DFC is issued to RAF officers for exemplary gallantry while flying in operations against the enemy (equivalent to the Military Cross for exemplary gallantry on land).

*RAF 161 Squadron*

John Devenish may well have flown Madeleine Damerment and Violette Szabo into occupied France — agents' names were never known to the crews. They would already be in the cockpit when the agent boarded. The crews themselves only knew at breakfast if they were dropping agents that night if they were served two eggs, instead of one.

It's only now, sixty-five years later, John's widow, Mrs Doris Devenish, who lives in Stevenage, can talk about those days. Her husband telephoned every evening. If no call came she knew he was on Special Duties (SD). She also knew he had a compass in the heel of his shoe and ransom money in case he was shot down.

Operating in all weathers without fighter escort, the heroism of the men of SD squadrons who undertook some of the war's most hazardous missions can never be overestimated.

161 was disbanded 2 June 1945 having made 1,749 sorties.

In June 1944, Violet Szabo and three other agents were flown from Tempsford. No good deed ever goes unpunished. After the war, the suggestion was put forward that the heroic pilots should be awarded a Croix de Guerre for services to France, but de Gaulle, jealous of SOE, refused. In September 1944, de Gaulle ordered all SOE agents to leave France, the country they helped liberate, immediately. With him long dead, it's still not too late to put things right.

*Flying Officer John Devenish with members of 161 Squadron and Tania Szabo*

Squadron 161 was known as The Moon Squadron because it could operate only when the moon was well up in the sky, especially during the few days before and after the full moon. Between 1941-1944, pilots made 800 clandestine pickups and deliveries from Tempsford.

The agent sat with legs dangling through a hole in the floor of the fuselage. From a tap on the shoulder from the dispatcher and the sight of a red light turning green the agent was pushed out. The parachute opened automatically when the weight of the agent's body pulled a static line attached within the plane. The agent was met by other agents and locals who risked their lives for being out after curfew.

On landing, Madeleine was taken to Gestapo HQ, Avenue Foch, Paris. Also there was Odette, Yolande Beckman, Eliane Plewman, Diana Rowden, Vera Leigh, Andrée Borrel and Sonya Olschanezky. They did not know each other as all did their training at different times. They talked about their suspicions — which proved correct — that an informant had betrayed them. Odette said the Avenue Foch was beautiful as was the house where they were incarcerated. She said one of the girls had a lipstick which they passed round and put on as a treat.

By March, Vera Atkins realised Madeleine had been captured. She sent two watches belonging to Madeleine to her Mother Superior. In the letter she refers to her as Miss Dussautoy. Sister Magdalen acknowledged their safe arrival saying she would keep them safe until Miss Dussautoy returned. The convent's notepaper shows the telephone number

Hitchin 471. In August, the Gestapo transported Madeleine, Odette, Vera, Andree, Sonya, Yolande and Eliane to a woman's prison in Karlsruhe, Germany. In an interview, Odette said, 'Everybody tried to be a little braver than they felt... there were a few tears... in the van from the Avenue Foch to the station we could get a glimpse of what was going on in Paris... On the train... each one of us handcuffed to somebody else... one of them even asked a guard for a cigarette, and he gave her one. We were frightened... wondering ... Were we going straight to our death?... Our only hope was maybe to be together somewhere.'

Chief wardress Becker remembered 'Martine' wearing a red jumper and carrying *The New Testament*. She said she was there for four months until she was taken by the Gestapo to her execution at Dachau concentration camp in Munich on 13 December 1944. She was twenty-seven.

In 1945, Nurse Hedwig Muller, who shared prison cell No. 17 with Madeleine in Karlsruhe, wrote to 'Mlle. Martine Dussantry [sic] c/o Reverende Mere Superior, French Convent, Verulem [sic] Road, Hitchin, Herts, England'. The post office (was it Hitchin Sorting Office?) intercepted the letter and sent it to SOE HQ in Baker Street, London for clearance before forwarding it to Mother Superior.

Nurse Muller, in prison for making fun of the Führer in public, said that, despite the granite walls being one foot thick, Madeleine managed to tap messages with her spoon in Morse code to Eliane Plewman her SOE colleague next door in cell No. 16 and to another prisoner, Lisa Graf, in prison for trying to shoot a German. Ms Graf said Madeleine had 'brown eyes... a nice smiling face... and dark hair...' Martine, she said, played hairdresser to the girls when she was not reading her rosary.

In 1946, the War Office wrote to Madeleine's mother, c/o Bureau de Postes, Marquette Lille, Nord, and to her sister Charline, 8 Rue de l'Eglise, Lille, telling her about Madeleine's capture and her murder by the Germans. Her father had been deported and died in 1945. It writes also to Rev Mother Superior, The French Convent, Verulam Road, Hitchin, and tells her Madeleine was shot in the back of the head at close range and cremated in Dachau camp crematorium. As Mother Superior of The Sacred Heart Convent in Verulam Road received the Croix de Guerre from de Gaulle for her work with the Free French, it may be she knew the truth about Madeleine.

In 1948, fifty-two women were commemorated on a plaque on the outside wall of St Paul's church, Knightsbridge (Wilton Place). The vicarage was the FANY HQ. It was unveiled by Princess Alice, Countess of Athlone, Commandant-in-Chief of the Women's Transport Service (WTS). The names include those of Violette Szabo, Odette Churchill and Madeleine Damerment who taught in a convent school in Hitchin.

In 1963, when Gibraltar Farm in Tempsford was given back to its owner, the Air Ministry gave a grant to return the site to its original, agricultural use.

Tania Szabo, whose father Étienne Szabo died during the war at el Alamein, emigrated to Australia with her grandparents. A writer and translator, she now lives in Jersey in the Channel Islands.

# CHAPTER 32

# MICHAEL FOOT

## (THE ONE WHO LIVES IN NUTHAMPSTEAD)

Professor Michael Richard Daniel Foot received a CBE for services to the Official History of the SOE; a Croix de Guerre for work with Resistance in Brittany; was made a Chevalier (Knight) of Légion d'honneur, the highest decoration France can bestow; and appointed to the Order of Orange-Nassau, the Dutch equivalent of the OBE. The honour was bestowed on members of foreign services who helped liberate the Netherlands from Nazi Germany occupation.

It's strange to think of a SAS war hero paratrooper enjoying quiet retirement in a chocolate box thatched country cottage until you remember he is living the idyllic end of life the traitor Kim Philby always hoped he would wangle. Having manipulated the system all his life this was one ambition even Philby could not pull off and he died desperately homesick thousands of miles away from the country he, bizarrely, loved.

Professor Foot, an SAS (the precursor of SAS was the SOE) intelligence officer was based at Moor Park. Involved in deception operations during D-Day, he was captured as a German prisoner of war, one of only 6 out of 100 SAS captives to survive. Although he helped plan Operation Titanic, he was not allowed to take part in it. Ten men went. Two came back. He said the lucky ones were killed in action; the unlucky were murdered in Belsen. He barely survived himself. His behind-the-lines mission to track down and capture or kill a notorious Nazi interrogator committing atrocities against British prisoners went badly wrong. Foot was captured as a German prisoner of war. On his fourth attempt to escape, French farmers armed with pitchforks broke his spine.

To mark the ninetieth birthday he surely once never expected to see, Professor Foot published an autobiography, *Memories of an SOE Historian*, recounting his experiences in clandestine warfare, resistance movements and the world of intelligence. In it he says the model for SOE was the early IRA.

Among his wartime anecdotes in a talk to the AGM of Hertfordshire Association for Local History (HALH) is a lovely one about plastic explosives. Explaining that one of its

*Nuthampstead*

variants is now known as Semtex, he said in those days it was a recently invented novelty. Not easy to set off, it needed a detonator so, unlike dynamite, was safe to carry around in the pocket. He said it looked like butter and felt like plasticine. One night in the dark, an SAS friend of his, assuming it was chocolate, ate it with no adverse results. Also, one freezing night on a mountain, one SOE agent found it made a warming fire.

Professor Foot, who spent much of his childhood at White Hill (demolished) near Berkhamsted Castle, is mentioned on page 561 of John le Carré's *A Perfect Spy*: ' "You're not M. R. D. Foot are you?" said Mrs Membury.'

In the 1950s, Dame Irene Ward, M.P., questioned the achievements of SOE which could not defend itself due to The Official Secrets Act. Indeed, for a long time after the war, the very existence of SOE was denied, despite its heroic success on the Nazi 'heavy water' plant in Norway and the assassination of Reinhard Heydrich, sub-human architect of The Final Solution. Prime Minister Harold Macmillan promised an official history of SOE in France.

The man chosen to write it was Michael Foot who held the modern history chair at Manchester. In 1966, his ground-breaking, revealing *History of SOE in France*, despite all bureaucratic attempts to muzzle him, was published to worldwide acclaim.

He has spent over forty years working on SOE writing books about the Second World War, including *SOE in the Low Countries*, *SOE: The Special Operations Executive* and *Art and War*. He has also written extensively on William Gladstone and was the first editor of *The Gladstone Diaries* (OU Press, 1968 onwards).

*SOE in France* tells how the SOE helped Britain win the war. In *Six Faces of Courage*, Professor Foot traces the secret lives of six members of European resistance movement, two women and four men, outstanding for their courage. He shows what was involved in wartime resistance, what affected success or failure: liaison with London, relations between groups and individuals, agents' methods of work, the organisation of particular networks and the perpetual counter-offensive of the Gestapo.

In 2006, Professor Foot wrote an obituary for Francis Cammaerts in *The Guardian* saying he was one of the star performers of F (France) Section of SOE. F was SOE Independent French Section (i.e. non-Gaullist).

At long last, the SOE has an official memorial. The sculpture of Violette Szabo on London's South Bank represents all who worked for the organisation. Not until October 2009, when the bust was unveiled, was SOE given public recognition.

# CHAPTER 33

# IAN FLEMING

## THE NAME'S FLEMING, PETER FLEMING

There is endless speculation as to who inspired 007. The odds are he was partly based on Fleming's brother Peter, a larger than life real special agent. Peter worked for MIR (Military Intelligence Research), a secret department within the War Office, for MI5, MI6 and for Churchill's SOE.

Peter Fleming was everyone's idea of a spy. Dashing, debonair, daring and very good-looking, like Bond he was a ladies' man who broke hearts. Ian Fleming, for many years in his shadow, was in awe of him.

Unlike action-man Peter, Ian Fleming, PA to the director of Naval Intelligence, spent his war pen pushing behind a desk. Not that his work was without excitement. Inspired by Peter's novel *The Flying Visit,* which imagined what would happen if Adolf Hitler's plane crash-landed in England and he was captured, Ian Fleming devised a plot with the novelist and one-time secret agent Alasteir Crowley to lure Hitler's deputy, Rudolf Hess, to Britain. On 10 May 1941, Hess flew to Scotland and was captured. When Churchill visited the Kremlin in 1944, Stalin proposed a toast to the British Intelligence Services, which he said 'inveigled Hess into coming to England'. When Churchill said the service knew nothing about it, Stalin suggested it had not told him.

Ian Fleming also devised the plot which became known as The Man Who Never Was. The corpse of an unknown 'officer' was washed up near Spain possessing false intelligence about Allied landings.

Fleming did not dream up the ingenious gizmos used by James Bond. His knowledge of espionage technology was based on first-hand knowledge. It was in Aston House, Stevenage, where they were manufactured he first saw secret service gadgets such as his treasured possession — a pen which ejected tear gas — and the Welrod, a single-shot pistol. Fitted with a silencer, it could be tucked up the sleeve (believed to still be in use to this day by Special Forces). Used by airborne troops it was made by BSA.

*The Frythe, Welwyn*

As Peter Fleming was in SOE, Ian, a high-ranking MI6 officer, had access to SOE Special Training Stations (STS) at Brickendonbury, Aston and The Frythe SOE Station 12. At The Frythe he would have seen the Welbike, the Welman and The Sleeping Beauty (a fold up submersible canoe).

The Welbike, a small folding motorbike with a 98cc engine, designed to be dropped by parachute to agents in occupied Europe was manufactured by Excelsior Motorbike Factory in Birmingham which had been producing bikes since 1896. It fitted into a cylindrical container, 15 inches in diameter to be dropped by parachute. The bike weighed 70 pounds, had a top speed of 30 mph and a fuel capacity of 90 miles.

As for the Welman, a one-man submarine, 100 were built by Morris, the Oxford car manufacturer. Professor Michael Foot tells the story of the day Lord Mountbatten was invited to try out the Welman. It sank with him in it, which meant he arrived very late and very wet for a meeting at Chequers. Foot says a friend of his has a Welman in his museum in Boston, Massachusetts.

Janet Surry, who lives in Hitchin, says that, when her husband, a horticulturalist, was appointed head gardener at The Frythe in the 1950s, one of his first duties was to camouflage the massive water tank in the grounds where tests were carried out

*The Frythe, Welwyn (2)*

on the Welman. He more than met the challenge. It's now a lake, part of a lovely terraced garden.

The Frythe is completely hidden from view even from the motorway. Small wonder the SOE chose it for secret operations. Even today, it is impossible to gain access, as it is to many of the other stately homes requisitioned in the war. Personnel charged with finding these places knew what they were about. To find them, even with the benefit of SatNav and postcodes, the photographer for this book went round in circles. He could be heard muttering 'it must be around here somewhere'.

Fleming certainly made good use of the limpet mine invented by Stuart Macrae who was based at Brickendonbury. The editor of *Armchair Science* was contacted by the War Office following an article he wrote about magnets. Then living in Bedfordshire, to test his limpet, he bought aluminium washing-up bowls in Woolworths and scoured sweet shops for aniseed balls. These were drilled and tiny detonator capsules were put inside. Strong magnets on the underside of the mine formed a curve which looked like a giant limpet.

His limpet mine was used by the famous Cockleshell Heroes who raided Nazi-occupied Bordeaux harbour and who, Churchill said, shortened the war by six months. In *Live and Let Die*, James Bond swims underwater to Mr Big's boat and plants a Limpet mine;

in *The Spy Who Loved Me* he fires a limpet mine dispenser; and in *From Russia with Love* Bey and his mistress are nearly killed when a limpet mine attached to the wall of his house explodes.

Fleming also had access to The Natural History Museum SOE Station IX demonstration rooms for secret inventions, such as explosives hidden in cow pats, rat skins, statues, radios hidden in books and secret inks.

James Bond's gadget supplier 'Q' was based on real-life inventor Charles Fraser-Smith, supplier of real-life 'Q' gadgets, described as Heath Robinson inventions. Peter Fleming particularly liked the poisoned arrows. Ian Fleming met Fraser-Smith in 1943 during the planning of Operation Mincemeat (The Man Who Never Was). Fraser-Smith supplied the air- and water-tight metal container which held the body of a man in British uniform put into the sea off the coast of Spain. On it was a detailed plan of the fictional invasion of Sardinia. The container packed with dry ice ensured the corpse would not decompose.

Neither Fraser-Smith nor his neighbour of over twenty years, forensic scientist Sir Bernard Spilsbury, knew, as they exchanged pleasantries on the platform waiting for their train into London every morning, that the other was working on Operation Mincemeat. To pass German forensic tests, a corpse with water in the lungs as if the man had drowned in the Mediterranean was needed. Spilsbury supplied it. The man, a vagrant, had died of advanced pneumonia.

Fraser-Smith lived in Croxley Green near Rickmansworth with his wife and two children. He was brought up in Hertfordshire where he lived until after the war. An unassuming George Smiley-type character playing the role of a minor civil servant, he travelled every day by train to his tiny office in the clothing department of the Ministry of Supply near St James' Park. This was a cover for his real work, the invention of ingenious gadgets for SOE agents. His hollowed-out hairbrushes, with no sign of a join, containing a silk map (made no noise when used) and compass, was copied from the one taken from Rudolf Hess when he was captured. Few, if any, of the small manufacturing firms he used around London had any idea of what they were making or why.

He called his inventions 'Q gadgets' after the warships disguised as freighters — Q ships — in the First World War. Confident of 'the unswerving logic of the German mind', he invented jacket buttons with a left-hand thread which hid tiny compasses. No German officer, he said, would ever unscrew an object the wrong way. He devised matches magnetised to work as compass needles, asbestos-lined pipes which could be smoked without destroying the map in the bowl, handkerchiefs with maps printed in invisible ink visible when developed by the agent's urine and garlic chocolate for agents dropped into France.

# CHAPTER 34

# ELIZABETH BOWEN

## MI5 Agent in Embryo

Like her close friend, the poet Louis MacNeice, the novelist Elizabeth Bowen is barely remembered today except by the older generation, yet in the 1950s and '60s both were at the very centre of London's literary world. Like MacNeice, Bowen was Anglo-Irish, worked for the BBC and for British Intelligence during the war.

The novelist spent the latter part of her childhood in Harpenden. Her father, an aristocrat, of Bowen's Court, County Cork, died young. In 1912, her adored mother Florence died of cancer, Florence's sister, a GP, Dr Constance Colley, died of TB, and her brother, Edward Colley, went down with the SS *Titanic* on his thirty-seventh birthday.

Bowen, thirteen, went to live in South View, Spencer Road, Harpenden, with her mother's remaining sister, Laura Colley, who kept house for her remaining brother, Revd Winfield Colley, a curate at St John's. Inside the church are memorials to Revd Colley and his brother Edward.

Harpenden remained Bowen's base until she married and had a home of her own (she kept her bank account there all her life). She was very happy and eternally grateful to Aunt Laura and Uncle 'Wink'. The first story she ever wrote, *Breakfast*, was in Aunt Laura's attic.

At Harpenden Hall School in South Downs Road, Bowen always wore a black tie to pay her respect to Florence, Constance and Edward. Harpenden Hall, built on what Bowen called 'the airy, gold, gorsy common', had been recently reopened as a girl's school. She loved it there and was very popular. She also loved secrets. A born leader, she invented schoolgirl crazes such as dabbling in black magic. She and her friends brewed magic potions, moaned incantations and buried a biscuit tin containing cryptic writing. Her short story *The Little Girls* is about her schooldays here.

Bowen, a close friend of Susan Buchan, was godmother to her son William and also to William's first child. When John Buchan was appointed Governor General of Canada, William stayed behind in London with Bowen. He was studying film directing at Elstree

*Harpenden Hall*

with Alfred Hitchcock, who became a family friend of the Buchan's after filming Buchan's *The Thirty-Nine Steps*.

During the war, Bowen moved in spy circles. A close friend of Graham Greene, she spied for Britain with MacNeice and John Betjeman, who she said was a silly man. Like MacNeice, she was torn in her allegiance between Ireland and England. However, as the body count in the Atlantic grew, by 1940, also like MacNeice, she disapproved of Ireland's neutrality. She wrote to Virginia Woolf '... I asked the Ministry of Information if I could do any work, which I felt was wanted in Ireland. On Saturday morning I had a letter from them saying yes, they did want me to go.'

She travelled regularly to Ireland reporting on the Irish attitude to the war; the prevailing climate of opinion; the temperature among writers and intellectuals in Dublin; and of country people near Bowen's Court, her home in Kildorrery, North Cork. She reported to Lord Cranborne whose ancestors, William and Robert Cecil, ranked among the greatest spymasters of all time. Cranborne reported directly to Winston Churchill.

In Ireland, like so many spies before and after her, research for books was her cover. She moved into Bowen's Court, which she had inherited, and wrote up its history. It was published in 1942 as was *Seven Winters* and *Memoirs of a Dublin Childhood*.

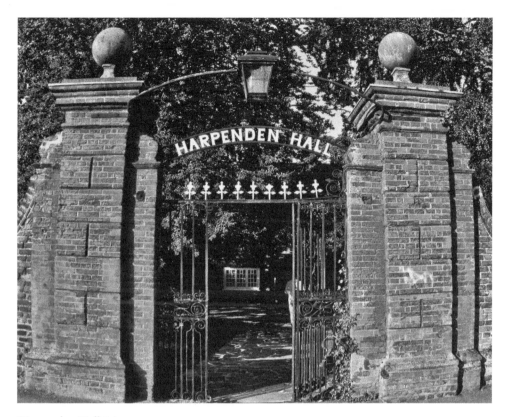

*Harpenden Hall (2)*

Her *Notes on Eire, Espionage Reports to Winston Churchill, 1940-2* contains some of the less sensitive secrets. Many in Ireland have never forgiven her. Although she was born in Dublin and spent her holidays on the family estate, they refuse to regard her as an Irish writer. She is barely mentioned in *North Cork Anthology* published in 1993.

She turned her experiences as an agent into *The Heat of the Day*, a novel about spying, considered the best book written about wartime London. It was reprinted five times in 1949, its year of publication.

In it, Stella, in a relationship with Robert, meets MI5 Agent Harrison who says Robert is spying for Germany but will not turn him in if she sleeps with him. Stella starts watching Robert, turning herself into a spy. Stella is Elizabeth and Harrison her lover Charles Ritchie, a Canadian diplomat she met in 1941 at John Buchan's house. She dedicated the book to Ritchie who was at her bedside when she died. Throughout her long, happily married life, she had many love affairs including a few in Ireland during the war.

# CHAPTER 35

# LOUIS MACNEICE

## — AND THE MACKEREL POEM

Louis MacNeice, poet and broadcaster, is barely remembered today except by the older, more literary generation, although in 2000 his poems 'Autobiography', 'Prayer Before Birth' and 'Soap Suds' were voted among the most popular in a *Radio Times* poll for The Nation's Favourite Poems of Childhood. Those who take the trouble to dig out his poetry will be pleasantly surprised.

MacNeice and the actress Mary Wimbush, Radio 4's *The Archers'* fans knew her as Julia Pargetter, bought 39, 41 and 43 Stocks Road (three cottages knocked together). Louis loved the house, the chapel next door, the old stocks and especially the Greyhound Inn where he always sat under the clock. He managed to reduce his drinking to two pints of Guinness at lunchtime and two in the evening. It's doubtful whether landlord or locals were aware they had a Titan in their midst, although the last landlord did take the clock with him when he left.

Louis, who wrote at home alone all day, was sustained by black tea and ginger biscuits until Mary came home from the BBC and cooked an evening meal. When writing, MacNeice saw and heard nothing. Mary once put a record on time after time to see if he would notice. He didn't. Commissions were flooding in and he completed three books here. One was on astrology so he bought Mary a gold ring with zodiac signs. MacNeice, who'd led a troubled life, was happier in Aldbury than he had ever been. Having his own home, somewhere permanent to live and a loving partner gave him stability.

In 1939, Churchill denounced Irish Prime Minister Eamonn de Valera for refusing to lease back the Treaty ports. During the Battle of the Atlantic, Ireland's neutrality was seen by Britain as a betrayal. Rumours abounded of German spies and parachutists being made welcome in County Kerry and County Cork.

In 1941, the BBC recruited MacNeice and George Orwell to write and broadcast propaganda. Dubbing it The Liar's School, they worked in Room 101. He continued to work for the BBC until he died.

*The Stocks, Aldbury*

After the fall of France, MacNeice worked for British Intelligence. Anglo-Irish, he was asked to go to Ireland and report back. Also there was Elizabeth Bowen and John Betjeman. When Ireland refused Jewish refugees entry, a disgusted MacNeice wrote about his problematic relationship with his Irishness and with Dublin.

> This was never my town,
> I was not born nor bred
> Nor schooled here and she will not
> Have me alive or dead

He also lambasted the country of his birth when casualties of submarine warfare began washing up on Irish coasts. Bodies and body parts were recovered in Donegal, Sligo and Mayo. A horrified MacNeice wrote 'Neutrality', castigating Ireland as:

> The neutral island in the heart of man
> ... to the west off your own
> Shores the mackerel
> Are fat — on the flesh of your kin.

*The Greyhound Inn, Aldbury*

This refers to rumours of fishermen selling their catches to German U-boat commanders. His *Autumn Journal* was reprinted five times during the war.

In 1945, as the first images of piles of murdered Jews in Belsen started appearing, Eamon de Valera visited the home of the German envoy in Ireland to offer his condolences on Hitler's death. He said the death sentences of Nazi leaders at Nuremberg were contrary to international law.

In 1958, Louis was awarded a CBE. 'Herself asked me "What do you do?" and I said "I do radio…" she said "Have you been doing it long?" ' HM had never heard of him. His CBE did not impress his employers, the BBC, 'We see Mr MacNeice that during the past six months you have produced only one programme. Can you tell us what you were doing the rest of the time?' His answer has gone down in the annals of BBC folklore. 'Thinking.'

His contract was cut by a half. Deprived of his staff job, a two-fisted drinker — whisky in one, Guinness in the other — and going without food, he sometimes ended up in police cells. Then along came Mary and Aldbury.

In June 1963, he covered President Kennedy's visit to Ireland for *The New Statesman* before writing what turned out to be his last play. It was about a potholer, so to get the right sound effects he went on 7 August with a sound recordist to Settle Caves in Yorkshire. Recording over, he went for a walk over the moors and was caught in a heavy

storm. Although soaked through, he didn't take off his wet clothes till he got back to Aldbury. By 11 August he was quite ill but when Mary urged him to go to bed he said 'I can't, I'm going to Ireland'. Back in Aldbury 20 August, he got worse. By 27 August, he was unable to breathe and agreed to go into hospital. Mary and his sister Elizabeth drove him to St Leonard's in Shoreditch where Elizabeth's husband, a senior surgeon, diagnosed viral pneumonia. Antibiotics had no effect. His constitution was undermined by alcohol and tobacco. His last BBC play, *Persons from Porlock*, was broadcast while he was in hospital.

Mary, at home in Aldbury, was making plans to put Sabre, their Great Dane, into kennels to move to London to be near him when her sister Joanna phoned from the hospital to say Louis was asking for her. He died 3 September. Mary lived in Aldbury until moving to Dorset in the 1990s. She is buried in Berkhamsted.

# CHAPTER 36

# JOHN BETJEMAN

## A POETIC SPY

When the IRA planned to assassinate John Betjeman, the operation was called off because Diarmuid Brennan, IRA head of civilian intelligence, was a huge fan of his poetry. He said, 'I came to the conclusion that a man who could give such pleasure with his pen couldn't be much of a secret agent. I may well be wrong'. He was.

In the 1960s, from his home in Stevenage, Brennan wrote to Betjeman to tell him how close he had been to death.

During the First World War, in school, because of his name — the original German spelling was Betjemann — he was bullied and called a spy. Ironic then that he did indeed become one. He worked for British Intelligence during the Second World War.

John Betjeman, poet, writer and broadcaster, had many connections with Hertfordshire. He knew it well. Betjeman talks about his childhood in his poems when he was embarrassed by his father on a shooting trip. As a boy he was very reluctantly taken out hunting with his father. John's father, Ernest, loved huntin', shootin' and fishin'. John did not. A humiliating experience while shooting in Buntingford with Ernest's close friend Philip Asprey, the jeweller, is immortalised in 'Hertfordshire'. 'I had forgotten Hertfordshire, The large unwelcome fields of roots, Where with my knicker bockered sire, I trudged in syndicated shoots...'

In 1929, he became a teacher at Heddon Court, Barnet. He blagged his way through the interview by pretending to love cricket. The anecdote is recorded in 'Cricket Master' *(An Incident)*. This is where he met the now famous Vera Spencer Clarke also mentioned in the poem. He also writes about the county in: *School Train; The Garden City; The Plansters Vision; Group Life, Letchworth* and *The Outer Suburbs*. He immortalises Rickmansworth, Croxley Green, Chorleywood, Loudwater and Moor Park in his 1970s film *Metro-Land*. He loved Ashwell so much he made a video (now lost) of the village for the BBC. Although he disliked modern architecture, he did agree to open Campus West Library, Welwyn Garden City.

*Buntingford*

Betjeman knew just about everyone in the literary world including fellow spies Graham Greene, Elizabeth Bowen, Louis MacNeice, Evelyn Waugh and Compton Mackenzie. He was at Marlborough with MacNeice and KGB Agent Anthony Blunt. He also knew Guy Burgess. Betjeman acknowledged MacNeice as a brilliant poet; MacNeice dismissed his poems as 'nonsense' and said he was a misfit.

When war was declared, Betjeman tried to join up but was rejected. Just as well given his self-confessed non-prowess with a gun in Buntingford. Instead he was given a job in Films Division at the Ministry of Information (he dubbed it Minnie) where he shared an office with fellow spy Graham Greene. He advised the government about using films for propaganda and would later on carry out his idea in Ireland.

Chosen as the sort who would get on with the Irish he was sent there to report back. His cover was his genuine involvement with a lecture on Erasmus, which brought him in contact with bishops, cabinet members, their friends and relatives, and movers and shakers within the Roman Catholic Church. Keeping his ear to the ground, he gained an insight into their views of the war and on Irish neutrality.

On the strength of his report, he was appointed Press Attaché to the High Commission in Dublin. His wife was not pleased to have to move there with their son Paul. Their daughter Candida was born there.

He said that during the war there were four categories of Irish:

1. Pro-British with relations fighting but above all pro-Irish
2. Pro-Irish, not caring who won, as long as Ireland survived
3. Pro-Irish, anti-British, anti-German
4. Pro-Irish, pro-German

He learnt Gaelic travelling to classes by bus. Passengers helped him with his homework. At his farewell party, he sang sixteen verses of a folk song in Irish.

Although Ireland was neutral, when double Agent Eddie Chapman was sent from Germany to blow up the de Havilland aircraft factory in Hatfield, he was told that when he was ready to return he was to go to Ireland where loyal Irish friends of Germany would help him. After the war, Ireland offered sanctuary to Nazi SS war criminals.

The Roman Catholic Church in Ireland was, like Hitler, fiercely anti-Semitic and did not express disapproval of the holocaust. In fact, it flatly refused to believe the authenticity of news footage on the liberation of Belsen. Wireless transmitters were used by German sympathisers in espionage against Britain. Charlie Chaplin's send-up of Hitler in *The Great Dictator* was banned.

Betjeman's rôle was to sway Irish public opinion in favour of the British. The seemingly absent-minded poet who wore a permanent expression of bewilderment was in reality a serious, efficient agent, even though he could not resist signing himself off as 'Sean O'Betjeman' in Gaelic. He vetoed a government plan to insert propaganda leaflets into packets of tea, soap and toilet paper. His reports on Irish politics were based on personal contacts within the Irish government and the Irish Republican Army (IRA).

Betjeman's main source of information came from the Palace bar, a Dublin pub where fellow poet Brendan Behan, a member of the IRA, held court. Betjeman was very popular and endeared himself to the Irish. When he arranged for Dublin artist Jack Yeats to have an exhibition at The National Gallery, he won friends for the UK. He became even more popular when he arranged for Laurence Olivier to film *Henry V* — a tale of a beleaguered England outnumbered by enemies — in Ireland. The yeomen who faced the French at Agincourt were local farmers who were paid extra if they provided their own horse. The film, a propaganda coup, added £80,000 to the Irish economy — a huge amount at the time. Betjeman said one friend gained for England was one lost for Germany.

Betjeman was called back from Ireland to take up another hush-hush job in the Admiralty.

# CHAPTER 37

# ELIZABETH POSTON

## THE CAROL SINGING INTELLIGENCE OFFICER

In her home town of Stevenage composer Elizabeth Poston is remembered for 'Jesus Christ the Apple Tree', her beautiful, haunting Christmas carol. At the BBC, she is remembered for her astonishing work during the war while working for the intelligence services.

Poston never spoke about her war work. Apart from the Official Secrets Act, in her circles it was not done to ask questions. Not that she, naturally secretive, would have answered them. All she did say was, when she worked for the BBC, she was 'more or less under the Foreign Office direct because there had to be a musician there'.

In 1939, the BBC World Service at Bush House asked Poston to join the staff for unspecified secret work. She said she accepted as it was either that or join the Land Army. Her official, invented, title London Director of Music European Service was her cover. What she was really doing was, under Churchill's orders, sending coded musical messages to resistance movements on the continent.

When the BBC started to broadcast music banned by the Nazis to boost the morale of Allies and resistance groups in occupied Europe, Churchill devised a scheme whereby coded messages could be inserted into gramophone records. The BBC collaborated with the SOE to broadcast secret communications to agents in the field within public broadcasts at prearranged times which could be deciphered only by those who held the code. The first bars were from Beethoven's 5th Symphony.

This system eliminated the need for the intricate coding and decoding necessary in sending Morse messages. A prearranged signal, meaningless to the enemy, gave an agent the clue for which s/he was waiting. The simplest example was the use of a harmless-sounding phrase on the French programme of the BBC, to confirm, as arranged with the agent, that a parachute operation was scheduled for that night. Agents would be on the alert for mention of words such as cow or strawberry *re* forthcoming drops. According to the records played, the message was either drops today or no drops today. From Bush House studios at 7.30 p.m. went silly messages such as '*Nanette porte un pyjama vert*'

*Rooks Nest*

which meant something to the reception committee. A further message on the 9.15 p.m. programme confirmed the operation (or, by the absence of a message, warned it had been cancelled).

The precise method used on gramophone records has never been disclosed. When we think of Miss Poston, it's hard not to be reminded of Miss Froy the secret agent in Hitchcock's *The Lady Vanishes* memorising and singing her coded tune in a wavery voice. As meticulous precision and concentration was essential in selecting the passages to be transmitted, Poston worked alone.

Poles working from Buckingham Palace delivered gramophone records to her at Room 6, Bush House, using the code-name Peterkin. Norman Peterkin was a close friend of Poston. In her wartime diaries is the entry 'Poles' every other Friday. She had a regular two weekly appointment at the hairdresser, strange for a woman whose hairstyle never changed and needed very little attention (she wore her long hair in a bun). After the war, Poston helped set up the BBC Third Programme.

Elizabeth Poston was a composer and an authority on British, European and American folk music. Born in Stevenage, she lived there all her life. In 1914, Elizabeth, her mother and brother moved into E. M. Forster's old home, Rooks Nest in Rectory Lane, Stevenage

(now called the old town), and this is where she died. Her mother was Forster's inspiration for Mrs Ruth Wilcox in *Howard's End*.

In 1991, when Malcolm Williamson, Master of the Queen's Music, moved into Rooks Nest, he found gramophone records with handwritten labels which Poston had edited for her coded messages.

In 2005, to celebrate her centenary, a DVD, *Elizabeth Poston at Rooks Nest*, was produced by Margaret Ashby for The Friends of Forster Country in Stevenage. Ms Ashby who knew her said that Poston once demonstrated how the music code system required a gramophone needle be placed at a precise point on the record. This was marked with a china graph pencil showing where the music was to begin. She also said that Poston's secret work triggered a nervous breakdown.

# CHAPTER 38

# DAVID HOLBROOK

## The Intelligence Officer and the Parish Fête

Parish councillors are not always what they seem. How many Ashwell parishioners in the 1960s knew that, during the war, the dedicated councillor who helped secure a grant for the village hall was an intelligence officer and a very brave one?

As an officer aged twenty-one, he took part in Operation Overlord, the invasion of Normandy on D-Day in 1944, landing at H plus five with his squadron of amphibious tanks; the perfect waterproofing for them was provided by Charles Fraser-Smith of Croxley Green.

*Nothing Larger Than Life* is a fictionalised autobiography about his twenty years in Ashwell where he lived in a medieval house, Ducklake, with his wife Margot and his four children.

Called up to train at Sandhurst in armoured warfare, David Holbrook joined the East Riding Yeomanry, which was preparing to invade Europe with floating tanks. These were 30 tonne Sherman tanks fitted with inflatable canvas sides, huge canvas boats with a 30 tonne keel. They floated ashore in Normandy from a large pontoon onto the beaches at about 2 p.m. on D-Day. After a horrendous two weeks in the beachhead David Holbrook returned to England wounded. He wrote about his experiences in *Flesh Wounds*, one of the best eyewitness accounts ever penned. He says when he reads it now it makes his hair stand on end. He has also written very moving war poems. Holbrook was sent back to the Ardennes as an intelligence officer then on to the Rhine helping refugees near Kiel, where the harbour was full of sunken ships.

In 1954, he was appointed tutor at Bassingbourn Village College arranging classes there and in the surrounding villages. In the 1960s, Holbrook and his friend the composer Elizabeth Poston co-authored the *Cambridge Hymnal*. They also wrote a cantata inspired by the medieval graffiti in Ashwell church for the 1968 Ashwell Festival. Did they know that during the war each had worked in Intelligence?

*Ashwell Parish Fête*

Poet, novelist, educationist, Emeritus Fellow, Downing College, Cambridge, David Holbrook has written many books on the teaching of English, ten novels, eight volumes of poetry and numerous books of literary and musical criticism. In his book *English for the Rejected*, David Holbrook pleads for the recognition of the importance and dignity of the children in the lower streams of comprehensive schools.

# JILL GREY

## The Amazing Mrs Grey

Just who is this Jill Grey who has a Place in Hitchin named after her? Local councillor? No. One of the saviours of The British Schools in Queen Street who once said she was conceived in the Sun Hotel, Hitchin.

Described as eccentric, extraordinary and gifted, Jill Shepherd — her maiden name — was involved in highly secret work during the war. As Women's Auxiliary Air Force (WAAF)

*The Sun Hotel, Hitchin*

officers were debarred from flying, Jill Shepherd started the war operating telex machines on the south coast before joining the Signals Branch as a Code and Cipher (C and C) officer. The C and C department started three days after war was declared. The first WAAFS to go overseas were C and C officers. It's rumoured that Miss Shepherd was attached to Sir Winston Churchill's war cabinet and went with him to the Tunis, Yalta and Potsdam conferences to handle his secret signals traffic.

After the war, she married and settled in Hitchin with her two daughters. As Mrs Jill Grey, she went to America as personal assistant to the inventor of the jet engine, Wing Commander Sir Frank Whittle, on a lecture tour to raise funds for his engine. He was negotiating with American companies who wanted to use his invention. Frank Whittle also lived in Hitchin for a while at 41 Bearton Green.

When Mrs Grey became interested in the history of education, she began collecting artefacts, books, postcards, furniture and costumes. An acknowledged expert, she was often consulted by the V&A and the BBC.

In 1969, The British Schools in Queen Street closed. By 1975, Mrs Grey had managed to get it listed. She opened a museum of education there in 1979 and wrote to Professor Lord Asa Briggs about it. The Lancasterian Classroom, built to accommodate 300 boys, is probably the only one left in the world. The Victorian Gallery Classroom is probably the only one of its kind left in the UK. Jill Grey left her collection, one of the most significant and comprehensive of its kind, to North Herts District Council.

# CHAPTER 40

# KING MICHAEL OF ROMANIA

## THE KING AND THE EGG MARKETING BOARD

Twenty-year-old Michael of Romania was the only constitutional monarch to lead his people in person during the Second World War. Helped by the Romanian Resistance, he led a successful *coup d'état* against the Germans.

In 1947, Stalin overran Eastern Europe. The Communist Party told King Michael that, unless he abdicated, a thousand students arrested during anti-Communist demonstrations would be tortured and killed. He did as he was told. He was in exile for fifty years.

In July 1952, the king, Queen Anne, Crown Princess Margarita and her sister Elena moved into Ayot House, Ayot St Lawrence, to tend chickens and grow vegetables. They stayed four years. While there, the devoted couple had another daughter, Irina, and would go on to have two more.

Princess Margerita's grandmother, Queen Helen, was a cousin of Prince Philip, her godfather. Her great-great-great-grandmother was Queen Victoria. Margerita, eighty-first in line to the British throne, studied at Edinburgh University for five years with her then boyfriend Prime Minister Gordon Brown.

Margerita said that although her father felt very isolated, didn't speak a lot and didn't have any friends, Ayot was therapeutic for him. He went to London every week to supervise the secret Romanian Resistance movement.

In 1954, Prime Minister Sir Winston Churchill received a letter from a well-wisher saying that, although King Michael and his family paid National Insurance and did not expect special treatment, it was a pity Britain lagged behind other countries in generosity towards royalty in exile. A stingy British government offered the king free identity documents and exemption from vehicle licences. The British people on the other hand, famous for their generosity, supported Romania. They drove relief convoys there after the fall of Communism, despite there being no historical links with the country.

Churchill wrote to Sir Anthony Eden, the foreign secretary:

*Ayot House*

> I have much sympathy with the King of Romania who acted with courage in the difficult situation of his country and was most ungratefully treated by the Soviet. I hope he may be considerately and courteously treated during his exile, which may not be permanent. I do trust that he can be accorded diplomatic privileges to the utmost possible extent. I should be glad if you would turn a friendly eye on this exceptional case.

Confidential Foreign Office documents recently released reveal that the exiled monarch was experiencing 'serious financial difficulties... his income is now down to £1,200 a year. He clearly cannot support his wife and children and meet his other commitments on this figure'. But it stressed that, as there was 'no precedent for special legislation on behalf of an exiled monarch', little could be done.

The files contain a letter which says, 'Mr Eden has been considering what can be done to assist King Michael. He thinks that he should be encouraged to take a job. King Michael is a qualified air pilot...' In 1956, the king did just that. He accepted an offer of a job as a test pilot for a commercial airline in Geneva.

In 1990, the king went home but was expelled the following day. He was eventually allowed to return in 1997, having promised to abide by the country's republican constitution.

King Michael and Princess Anne of Bourbon Parma fell in love when they were guests at the wedding of HRH Princess Elizabeth and HRH Prince Philip. They sat at the top table with the bride and groom, George VI, Queen Elizabeth, Queen Mary, Princess Margaret, Princess Andrew of Greece, Prince George of Greece and the kings of Norway and Denmark.

The king rented the large, cold, damp and empty Ayot House from its owner Lord Brocket of nearby Brocket Hall. The impoverished couple, who could not afford to switch on the heating, grew vegetables, roses and chrysanthemums and sold them in markets. They started a poultry farm by converting the barn into a hen house and put wire netting around the tennis court for a chicken run. They did everything, prepared the feed and cleaned and packed the eggs, which the Egg Marketing Board collected. For the first time since his exile the king was happy. The children loved it all and often popped over to feed the birds at nearby Shaw Corner. Their mother read them Beatrix Potter stories and made them wooden jigsaws.

Nearby was an aero club where the king, a keen pilot, often flew. He took enormous interest in the de Havilland factory and the new Comet engine.

Romania was led after 1965 by the dictator Nicolae Ceausescu. He was executed 25 December 1989. In 1997, the king was allowed home for a visit after fifty years in exile.

In 2001, King Michael, seventy-nine, was welcomed back to Romania as honoured guest of President Iliescu to visit his old palace. On 1 January 2007, Romania joined the European Union. King Michael has now received back two castles. You can see the king and his family at Ayot House on British Pathé News.

King Michael now lives in Switzerland.

# CHAPTER 41

# JOHN LE CARRÉ

## GEORGE SMILEY COMES TO SARRATT

John le Carré/David Cornwell worked for MI6 in Bonn and Hamburg. His career as a secret agent was brought to an end by Kim Philby who blew the cover of British agents to the KGB. When Philby defected to Moscow, he invited Cornwell to visit him. The invitation was turned down. Philby is Gerald, the 'mole'— a concept invented by le Carré — hunted by George Smiley in *Tinker Tailor Soldier Spy*.

A real life spook, David Smiley was in SOE. The word 'spook', like 'mole' — as in spy — was also invented by le Carré; these words have now entered the English language. The larger-than-life Colonel David Smiley, OBE, MC and Bar, a member of SOE, was one of the most famous agents ever. It would be astonishing if John le Carré did not know him or at least of him. Is le Carré's Smiley a homage?

When le Carré chose Sarratt as the location for his spy school, he called it The Nursery after Lord Milner's kindergarten of real spies. He is a fan of John Buchan who was a member. He mentions Sarratt many times in his books:

> Sarratt went to the devil long ago; only the other day a young probationer just out of the circus refurnished training school at Sarratt in the jargon again, The Nursery; at Sarratt they wouldn't have even seen it coming; Sarratt nursery for some reason… is carried on the military budget.
>
> *The Honourable Schoolboy*

> For four days Sarratt was limbo.
>
> *Smiley's People*

> The annual Sarratt cricket match had to be postponed three Sundays in a row; you remember what we used to say at Sarratt?
>
> *Tinker Tailor Soldier Spy*

*Sarratt*

Leamas glanced at the number, went over and called through the window, 'Are you from Clements?'

<div align="right">

*The Spy Who Came in from the Cold*

</div>

Clements was Clements department store in Watford, affectionately referred to in those days as the Harrods of Watford. Clements was David Cornwell's link with Sarratt.

In 1963, when *The Spy Who Came in From the Cold* was published, le Carré denied any connection with the secret service but now freely admits he was in MI5 and MI6. Le Carré was interested in fellow spy Compton Mackenzie. 'When I was in MI5,' he said in an interview, '… one night, as duty officer, tiptoeing through the archives… I read correspondence between C, head of the secret service, and the director general, head of the security service, about "this swine Compton Mackenzie".'

He says he has told so many lies about why he chose his pseudonym he has now forgotten the real reason. One story goes that when he began writing and needed a pseudonym, because his boss said he was a 'square', he called himself le Carré (French for square).

His father was the conman in *A Perfect Spy*, the nearest le Carré has got to his autobiography. He disliked Ian Fleming's world of spying so developed anti-James Bond characters such as George Smiley in *Call for the Dead* (1961).

The Sarratt trilogy documents the Cold War. It starts with *Tinker Tailor Soldier Spy*. Smiley, retired from the Circus — as the secret service is known —is asked to help when a mole leaks Circus secrets. Smiley's opposite number in Russia is Karla. Their enmity continues in *The Honourable Schoolboy* (1977) and culminates in *Smiley's People* (1980) when Smiley forces Karla to defect to the West.

Why did le Carré choose Sarratt for his spy base? Because one of his closest friends lived there. In 1951, in Switzerland, Cornwell, a ski-racer representing Britain, met fellow ski-racer Dick Edmonds whose family owned Clements, the Watford department store. When they returned home, le Carré wanted to buy a suit he saw in Clements window and so worked in the store during its summer sale to pay for it — which is, he says, how the 'spy who came in from the cold' came to sell bath towels.

Edmonds, to help his financially embarrassed friend, commissioned him to paint a mural for the concourse showing shoppers trooping through Clements' doors. He said if le Carré had not become a famous writer he would probably be a famous painter because he is very, very good. However, Edmond's father, who was not enamoured of his son's impecunious friend, said it insulted his customers who looked like leering peasants and ordered its removal.

Each evening, after work, the lads squashed into Edmonds' two-seater Triumph Roadster (Registration OPA 3) and careered around Hertfordshire. Le Carré said, 'Sarratt... impressed itself upon me as some kind of secret haven, a forgotten place of real England... twenty years later... I called my training school the Nursery. And I put it in Sarratt where I had once longed to live. In the world of George Smiley... there is no place more dangerous than home.'

He told the story in *Sarratt and the Draper of Watford*. The draper, of course, was Dick Edmonds who, unlike le Carré, ended up living in Sarratt. He and his wife Sarah moved there in 1961, about the same time le Carré started writing spy books. Also in the book is a story about one of literature's most famous double acts, Smiley and his adversary Karla, once separated by the Iron Curtain. It was written by Russian defector Colonel Mikhail Lyubimov (KGB friend of English defector Kim Philby). Posted to London in 1961, the character of Karla was based on him. Russians are said to admire le Carré's Cold War spy stories, especially the Smiley/Karla trilogy. Ex-spooks say they are so near the truth it's as if le Carré was in the room as they hatched their plans. Sarratt is mentioned many times throughout the trilogy.

In *Tinker Tailor Soldier Spy*, Smiley reminisces about the Sarratt he knew before the war. 'Sarratt Nursery was the training compound...'

The character Alleline was posted there to take over the training of 'greenhorn probationers' and Smiley vetted recruits such as Ricki Tarr there. Connie Sachs, who had her photo taken there on a summer course, said that, when a defector told his inquisitors about a new training camp outside Moscow, it sounded like a 'sort of millionaire's Sarratt'.

Peter Guillam was trained there, as was Bill Haydon and Roy Bland before being sent to Poland. Bland, an alcoholic, went back to Sarratt to be dried out. When Jim Prideaux was debriefed at Sarratt, he said he 'walked around the cricket ground'. Prideaux as a teacher punished Clements, the draper's son, and read John Buchan stories to his pupils. When Smiley visited Haydon, he noticed it was a 'sorry place after the grandeur…'.

The seen-better-days bench on Sarratt Common brings to mind an incident in one of le Carré's stories. Although George Smiley had specifically asked Lacon to take extreme care of Bill Haydon's physical safety while he was at Sarratt, Haydon was murdered on a 'garden bench facing the moonlit cricket field'.

In *The Honourable Schoolboy*, Jerry Westerby calls himself 'Sarratt Man'. When he met up with Smiley at Sarratt after the war they searched for '… good places to look for dead letter boxes'. A young probationer just out of the Circus's refurbished training school said that '… the Dolphin case had recently been introduced at Sarratt'. Sarratt training '…included much to be memorised… phone numbers, word codes and contact procedures'. Airline pilots, journalists, spies, the Sarratt doctrine warned, 'experience inertia interspersed with bouts of bloody frenzy'. In *Smiley's People*, Mostyn says, 'I heard you lecture at Sarratt sir; the Sarratt training course all over again'. Connie remembers: '…the annual Sarratt cricket match had to be scrapped three Sundays in a row.'

Cornwell's friend Dick Edmonds, High Sherriff of Hertfordshire in 1991, said he couldn't understand the Smiley books but did enjoy *The Constant Gardener*.

# CHAPTER 42

# JOHN PROFUMO

## THE COLD WAR COMES TO WESTMILL

Sexual intercourse began
In nineteen sixty-three
Philip Larkin, 'Annus Mirabilis'

In 1963, John Profumo told the House of Commons there was 'no impropriety whatever' in his relationship with Christine Keeler. Ten weeks later, he appeared again to say he had misled the House. Profumo, an M.P. for twenty-five years, resigned as Secretary of State for war, as an M.P. and was removed from the list of privy councillors.

Lord Denning's Report describing the extraordinary sexual behaviour of high society rocked the country. More worrying were concerns over the nation's security. At the height of the Cold War, this was bigger than a mere sex scandal. George Blake, British diplomat and KGB agent, had been recently jailed for forty-two years; Admiralty clerk William Vassall was jailed for eighteen years for spying for the Russians; and Kim Philby was named as the 'third' man in a Soviet spy ring. In Berlin, Russia had built a concrete wall between the Soviet and western sectors and the Cuban missile crisis had brought the world close to nuclear annihilation.

This was the political climate when, with the tabloids hounding him in a mass media frenzy, John Profumo went to ground in The Dower House in Westmill. It was very well chosen. Even today, unless one is in the mood for a bit of trespassing, the house is almost impossible to access.

John Profumo and Eugene Ivanov, soviet spy and military attaché at the Russian Embassy, had both slept with prostitute Christine Keeler. Ivanov had asked Keeler to find out from Profumo when the USA planned to equip the West German air force with nuclear weapons and bugged her bedroom.

Profumo, the youngest M.P. during the war, a brigadier at thirty, was rising through the ranks of the Conservative Party when he met Christine Keeler. Bill, Lord Astor, close

*Westmill*

friend of HRH Prince Phillip and Lord Mountbatten, worked in Intelligence during the war. MI5 used his Cliveden estate as a honey trap for foreign agents and used high society osteopath Stephen Ward and his girlfriends.

Ward, recruited by MI5, knew Guy Burgess, Donald MacLean and Anthony Blunt. MI5 hoped to 'turn' Eugene Ivanov by providing him with a 'popsy' at Cliveden. On the weekend in July 1961, when Keeler slept with Profumo at Cliveden, she also slept with Ivanov.

Her live-in lover was John Edgecombe, a West Indian. Before him was a London gangster, Lucky Gordon. Edgecombe was jailed for seven years after shooting at Keeler when she was staying in Ward's Wimpole Street flat. She was smuggled out of the country and into Spain by Paul Mann, a racing driver believed to have been paid by MI5.

The public fascination with the scandal was so great that hundreds queued all night to buy Lord Denning's Report. 100,000 were sold. Denning ordered the Profumo papers be sealed until 2046.

It's said that MI5 chief Sir Roger Hollis hatched a plot to persuade Ivanov to defect. Keeler said Stephen Ward was a double agent and asked her to get information from Profumo about nuclear warhead deployments in West Germany. She said he was in a spy ring which included Hollis and Blunt, surveyor of the Queen's pictures. Peter Wright said in *Spycatcher* that Hollis was a double agent.

Prime Minister Harold Macmillan resigned shortly after the crisis. Harold Wilson won the next election. M.P.s Barbara Castle, George Brown, Jim Callaghan and Denis Healey rose to power on the back of the most sensational scandal in modern British politics.

CIA still has a dossier called Bow Tie on Stephen Ward who provided, via Lord Astor, a 'popsy' for President Kennedy when he was in London. Kennedy is said to have shocked Prime Minister Harold Macmillan by telling him he got a headache if he did not have regular sex.

When Stephen Ward committed suicide, Keeler sold Profumo's letters to the newspapers then disappeared. It's rumoured that she turned up living not far from Profumo in Westmill.

In 1971, 105 Soviet personnel were asked to leave the UK. In 1975, Valerie Hobson accompanied her husband to Buckingham Palace when he received a CBE for his work at Toynbee Hall. In the 1980s, Anthony Blunt was revealed as a long-time Soviet agent. In 1989, a film called *Scandal* was made about the liaison between Keller and Profumo.

The pretty, chocolate box village of Westmill was a haven for John Profumo and his actress wife. They lived there for fifteen years and settled in well to village life. Were villagers horrified by the scandal? On the contrary, many had been brought up on the films of Valerie Hobson and admired her. Even today, they recall the couple with affection. The beautiful, elegant Mrs Profumo often accepted an afternoon cup of tea with neighbours sitting and chatting over the kitchen table.

Their son David said that out of the destruction of their shattered lives came creation as they redesigned the house and five acres (it had once been a market garden). The house received a new façade constructed with specially hand-made bricks and the couple scoured antique shops for furniture. Gardening in old corduroys and T-shirts became one of Profumo's new passions. The other was Toynbee Hall where he worked until he died. Mrs Profumo, who also did charity work for mentally handicapped children and for Lepra, a leprosy relief organisation, won respect for her loyalty to her husband.

Dinner parties at the Dower House — small, intimate affairs — included loyal friends Margot Fonteyn, Selwyn Lloyd, Ted Heath, Henry Moore, Kenneth Clark and Paul Gallico.

When David and his half brother, Mrs Profumo's son by a previous marriage, moved out, with Profumo spending more and more time in London because of his work at Toynbee Hall, Mrs Profumo, distressed by two burglaries, moved back to London.

David Profumo said his father had an eye for pretty women until the day he died in 2006 age ninety-one. Even in old age, he was not averse to pinching the bottoms of waitresses when dining out.

# BIBLIOGRAPHY

Alabaster, Dr John S., *Elizabeth Poston Centenary*, The Friends of Forster Country, 2006

Ashby, Margaret, *Forster Country*, Flaunden Press, 1991

Aubrey, Philip, *Mr Secretary Thurloe*, The Athlone Press, London, 1990

Beamon, Sylvia P., *The Royston Cave*, Cortney Publishers, 1992

Beamon, Sylvia P., *Exploring Royston Cave*, Royston & District Local History Society, 1998

British Pathé News

Buchan, John, *Mr Standfast*, Wordsworth Classics, 1998

Cook, Andrew, *M: MI5's First Spymaster,* Tempus, 2004

Crawford, Rosemary and Donald, *Michael & Natasha*, Orion, 1997

Du Maurier, Daphne, *Golden Lads*, Virago, 2007

Fanshawe, Lady Anne, *Memoirs*, Central Resources Library Hatfield

Foot, M. R. D., *SOE The Special Operations Executive 1940-46*, BBC, 1984

Foot, M. R. D., *Memories of an SOE Historian*, Pen & Sword Military, 2008

Fraser-Smith, Charles, McKnight, Gerald and Lesberg, Sandy, *The Secret War of Charles Fraser Smith: The 'Q' Gadget Wizard of World War 11*, The Paternoster Press, 1981

Glendinning, Victoria, *Elizabeth Bowen*, Phoenix, 1977

Greene, Graham and Hugh, *The Spy's Bedside Book*

Helm, Sarah, *A Life in Secrets,* Abacus, 2006

*Herts Past & Present*, Issue No. 8, Autumn 2006

Holbrook, David, *Flesh Wounds*, Methuen, 1966

Howarth, Patrick, *Undercover: The Men and Women of the SOE*, Weidenfeld & Nicolson, 2000

Jones, Terry, *Who Murdered Chaucer?*, Methuen, 2004

Khan, David, *Seizing the Enigma*, Arrow, 1996

Knightley, Phillip, *The Master Spy*, Vintage, 1990

Le Carré, John, *Tinker Tailor Soldier Spy*, Sceptre, 2006

Le Carré, John, *The Honourable Schoolboy*, Sceptre, 2006

Le Carré, John, *Smiley's People*, Book Club Associates, 1980

Le Carré, John, *Sarratt and The Draper of Watford*, HALS County Hall Hertford, 1999

Macintyre, Ben, *Agent Zigzag*, Bloomsbury, 2007

Miller, Russell, *Behind The Lines*, Pimlico, 2003

Porter, Ivor, *Michael of Romania*, Sutton, 2005

Pearson, John, *The Life of Ian Fleming*, The Companion Book Club, 1966

Profumo, David, *Bringing The House Down*, John Murray, 2006

Ryder, Sue, *Child of my Love: An Autobiography*, Harvill Press, 1997

Shelden, Michael, *Graham Greene, The Man Within*, Heinemann, 1994

Smith, Graham, *Hertfordshire and Bedfordshire Airfields in the Second World War*, Countryside Books, 2003

Smith, Janet, Adam, *John Buchan and His World*, Thames and Hudson, 1979

Smith, Lawrence, Dwight, *Cryptography, The Science of Secret Writing*, New York, 1943

Smith, Michael, *Station X*, Channel 4 Books, 1998

Turner, Arthur C., *Mr Buchan, Writer*, SCM Press, London, 1949

Turner, Des, *Aston House SOE Station X11*, 2004 (Richmond House, 2 Beningon Road, Aston Stevenage, SG2 7DX)

West, Richard, *Daniel Defoe: The Life and Strange Surprising Adventures*, New York, 2000

Whitmore, Richard, *Hertfordshire Headlines*, Countryside Books, 1987

Every effort has been made to obtain permission from owners of copyright material reproduced. The author apologises for any omissions and will be pleased to incorporate any missing acknowledgements in any future editions.